Hans Hofmann

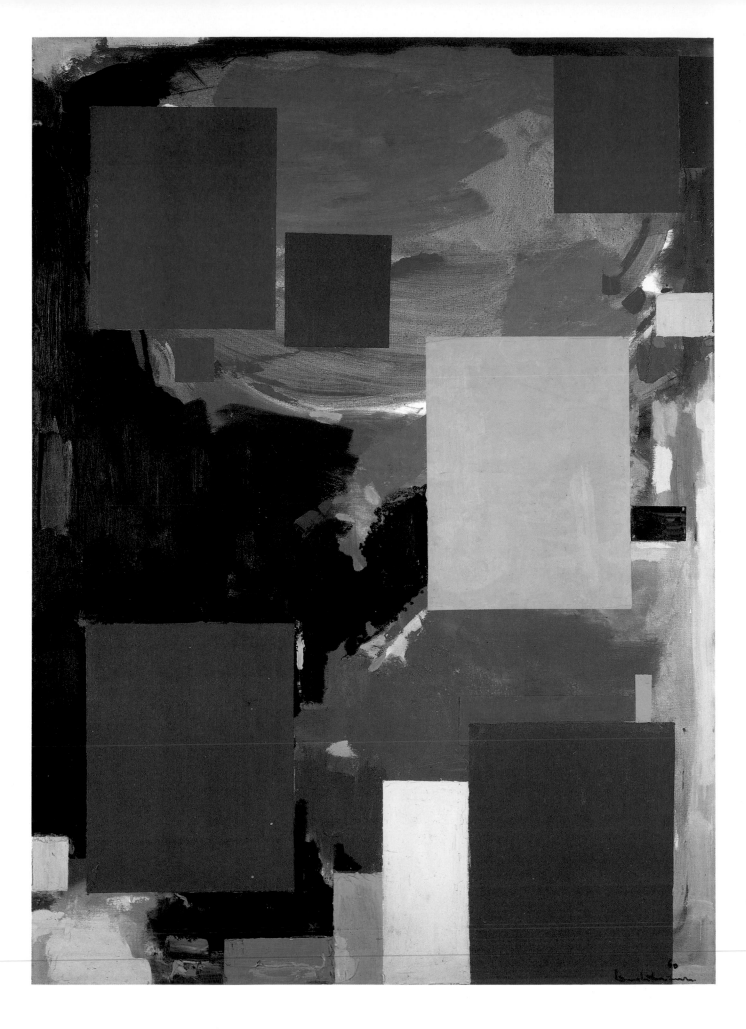

MODERN MASTERS SERIES

Hans Hofmann

Cynthia Goodman

ABBEVILLE PRESS · NEW YORK

Hans Hofmann is volume ten in the Modern Masters series.

To my parents

Acknowledgments: Many people have helped to make this book possible, but most especially Fritz Bultman and Lillian Kiesler, two of Hofmann's former students and closest friends, who enthusiastically and generously shared with me not only their memories but also all of their personal documents concerning Hofmann and his school. I owe my profoundest thanks to them. I am also grateful to Hofmann's many other students and friends who consented to be interviewed. It was Henry Geldzahler's interest in Hofmann that sparked my own, and I am thankful to him as well as to the Chester Dale Foundation, which funded two years of my research on Hofmann as a Chester Dale Fellow at the Metropolitan Museum of Art, New York. Jeanne Bultman, Helen Frankenthaler, Robert and Helga Hoenigsberg, Dr. John McCoubrey, Irving Sandler, Phyllis Tuchman, Robert Warshaw, and Micha Ziprkowski all gave helpful suggestions and encouragement. Mark Rosenthal was instrumental in making possible my initial research on the University Art Museum collection, and Sidra Stich helped in the final stages. André Emmerich and his gallery, especially Yun James Yohe, were most cooperative, as were John Sartorius and Richard Covey of the Hans Hofmann Estate.

Art director: Howard Morris
Designer: Gerald Pryor
Editor: Nancy Grubb
Picture researchers: Amelia Jones and Laura Yudow
Chronology, Exhibitions, Public Collections, and Selected Bibliography compiled by Cynthia Goodman

FRONT COVER: *The Lark*, 1960. Oil on canvas, 60⅛ x 52⅜ in. University Art Museum, University of California, Berkeley; Gift of the artist.

BACK COVER: *Idolatress I*, 1944. Plate 39.

FRONT END PAPER, left: Hans Hofmann in front of his house, Provincetown, 1960. © Arnold Newman.

FRONT END PAPER, right: Hans Hofmann inside his house, Provincetown, 1956. © Arnold Newman.

BACK END PAPERS: Hans Hofmann in his studio, Provincetown, 1960. © Arnold Newman.

FRONTISPIECE: *Goliath*, 1960. Oil on canvas, 84⅛ x 60 in. University Art Museum, University of California, Berkeley; Gift of the artist.

Library of Congress Cataloging in Publication Data

Goodman, Cynthia.
 Hans Hofmann.

 (Modern masters series, ISSN 0738-0429; v. 10)
 Bibliography: p.
 Includes index.
 1. Hofmann, Hans, 1880–1966. 2. Painters—United States—Biography. 3. Art teachers—United States—Biography. I. Title. II. Series.
ND237.H667G66 1986 759.13 85-22923
ISBN 0-89659-441-6
ISBN 0-89659-442-4 (pbk.)
ISBN 0-89659-606-0 (Berkeley ed.: pbk.)

Contents

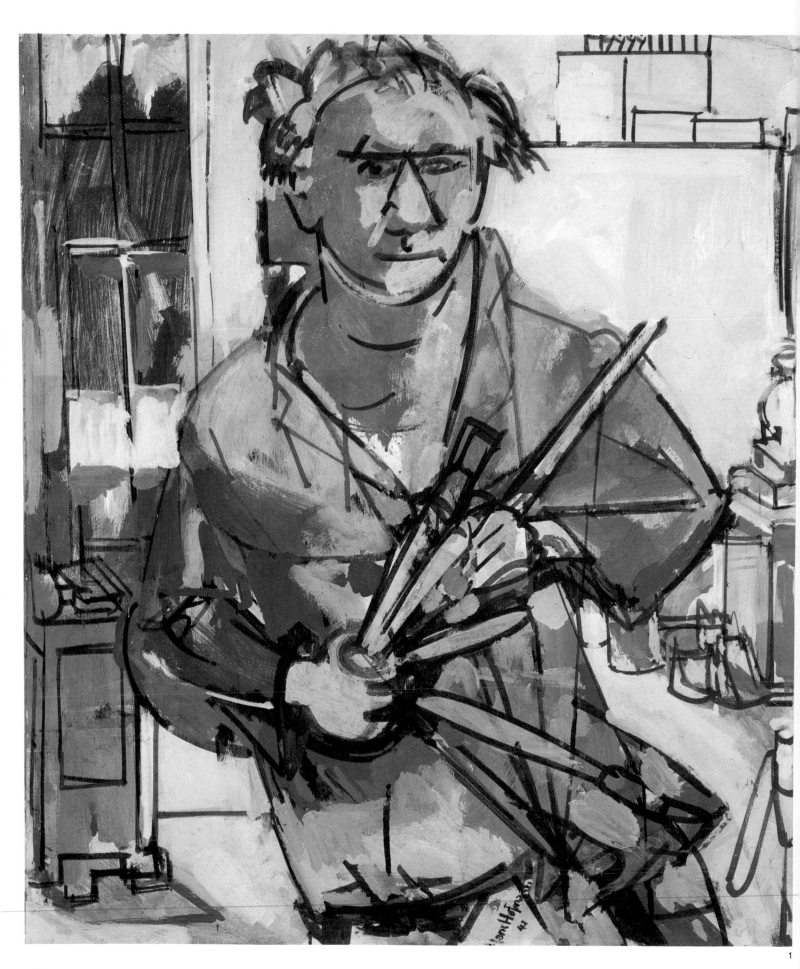

Introduction

Hans Hofmann was the only artist of the New York School to participate directly in the artistic revolution that took place in Europe during the first two decades of the twentieth century. While in his mid-twenties and thirties, he studied in Paris during that exhilarating period from 1904 to 1914 when Cubism, Fauvism, Futurism, and German Expressionism originated and flourished. The importance of what he learned there cannot be overestimated in its impact both on his own development and on the development of modern art in America, where he lived from 1932 to his death in 1966. Most of the artists in New York who yearned to know about contemporary innovations in Europe had to rely on illustrated magazines as their sole source of information. Hofmann's personal encounters with the avant-garde in Paris and Germany made him a much more direct and vivid source than the printed page, and it was his original synthesis of this richly complex heritage that made his contributions as both teacher and painter so significant. For many years Hofmann's skills as a first-rate artist were overshadowed by the great success of his schools, first in Munich, then in New York and Provincetown. As Hofmann once explained, "When I came to America, I presented myself not as a painter of a certain style but through the fame of my Munich school."[1]

Hofmann opened his own school in New York in 1933, in the midst of the Depression. Although he was enormously popular as an instructor, the school was to flounder financially for many years until the G.I. Bill, instituted after World War II to give veterans financial assistance with their education, brought an influx of new students. Virtually no New York artist in the 1930s was able to be self-supporting through the sale of paintings. While Hofmann chose to teach, many of his colleagues, including Willem de Kooning, Arshile Gorky, Jackson Pollock, Ad Reinhardt, and Mark Rothko, sought employment with the Federal Art Project of the Works Progress Administration after its establishment in 1935. The WPA fostered a sense of community among those who participated in its programs—a confraternity from which Hofmann was excluded.

Hofmann's reluctance to exhibit his work compounded the problem of his artistic reputation. Although large exhibitions of

1. *Self-Portrait with Brushes*, 1942
Casein on plywood, 30 x 25 in.
André Emmerich Gallery, New York

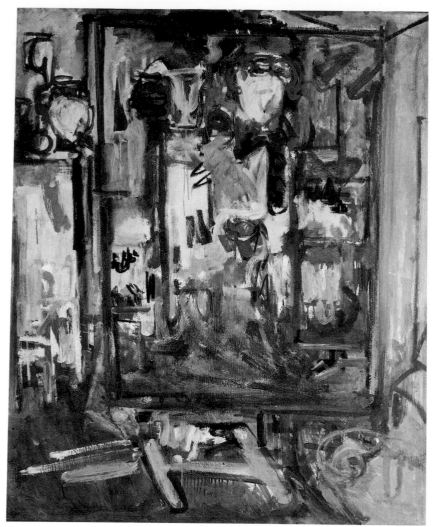

2

his art had been organized in San Francisco in 1931 and ten years later in New Orleans, it was 1943 by the time one of Hofmann's paintings was on public view in New York, and not until the following year did the sixty-four-year-old artist have his first solo New York exhibition at Peggy Guggenheim's Art of This Century gallery. Until this time he had allowed only a few close friends to visit his studio, a restriction he attributed to fear that his students might not develop independently if they saw his work. His hesitation was, in fact, justified: once Hofmann's paintings were publicly available, so many of his students slavishly copied them that Leo Steinberg dubbed their readily identifiable style "Hofmannerism."

Whether he acknowledged it or not, Hofmann's uneasiness at being evaluated as a painter by those who already revered him as a teacher must have reinforced his reluctance to let his art be seen. As soon as he began exhibiting it, Hofmann's work attracted widespread notice as well as somewhat qualified critical acclaim. That his teaching had previously seemed to take precedence over his painting was neither quickly forgotten nor forgiven. One review of Hofmann's show at Art of This Century exemplifies this attitude. The critic observed not only that a first exhibition for an artist of Hofmann's age and renown was a noteworthy event, but also that "Hofmann's staunch followers" had given rise to a "skeptical

2. *Interior Composition*, 1935
Oil on casein on plywood, 43⅜ x 35⅜ in.
University Art Museum, University of
California, Berkeley; Gift of the artist

3. *Reclining Nude*, 1935
India ink on paper, 8½ x 11 in.
The Museum of Modern Art, New York;
Gift of Philip Isles

3

opposition" who had "been asking monotonously for some ten years 'But can he paint?'"[2] With his second exhibition, at the Gallery 67 in 1945, Hofmann gained the support of the powerful critic Clement Greenberg, who lauded Hofmann as "in all probability the most important art teacher of our time." Greenberg also mentioned that he personally owed "more to the illumination received from Hofmann's lectures than from any other source" and that he found "the same quality in Hofmann's painting [as] in his words—both are completely relevant."[3] This review, however positive, again demonstrates how inextricably Hofmann's two careers were intertwined. Hofmann would struggle with the problems of his dual career for many more years, continuing to teach as well as to exhibit almost yearly until 1958, when at the age of seventy-eight he finally gave up teaching to devote himself to painting full-time.

It was not only his reputation as a teacher that impeded Hofmann's acceptance as a major painter. Hofmann obdurately resisted being identified with any one movement or style. His career was distinguished by his unusual ability to explore simultaneously what might be considered irreconcilable forms of expression. Yet this stylistic range was intrinsic to his way of working. Hofmann confided to Sam Kootz, his friend and dealer of many years, "If I

ever find a style, I'll stop painting."[4] Unfortunately, many mistook this diversity, which was central to Hofmann's creativity, as either indecision or artistic immaturity, a misunderstanding that obscured his artistic prowess. Although critics Thomas B. Hess and Harold Rosenberg became staunch Hofmann fans in the mid-1950s, it took Hofmann a long time to win their support and that of others such as painter and critic Walter Darby Bannard, who defended his stylistic plurality with the assertion that "it's the picture that is obliged to be consistent, not the artist."[5] Greenberg partially blamed the art-viewing public for not accepting the work of any artist who went beyond one easily identifiable style, but he did concede that "the variety of manners and even of styles in which [Hofmann] works would conspire to deprive even the most sympathetic public of a clear idea of his achievement."[6]

Some were put off by Hofmann's European mannerisms and by the occasional pomposity of his philosophical discussions, which were comprehensible only to those already well versed in his ideas. Yet Hofmann's theorizing was offset by his warm conviviality, expansiveness, and keen sense of humor. As a teacher, Hofmann fostered an infectious camaraderie, and he expressed a benign paternalism toward the dozens of students who became close to him. His magnanimous personality and unswerving conviction that art was essential to humanity inspired many of those who studied with him. Larry Rivers recalls that when Hofmann "came around to look at the work he was relaxed enough to beef up the timid hearts, and pompous, blustering, egocentric enough to make every

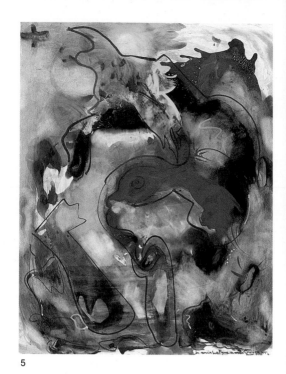

5

4. *Towering Clouds*, 1958
Oil on canvas, 50 x 84 in.
Collection Gordon F. Hampton, Los Angeles

5. *Intoxication*, 1945
Gouache on paper, 28¾ x 22¾ in.
Private collection

6. *Pastorale*, 1958
Oil on canvas, 60 x 48 in.
André Emmerich Gallery, New York

4

fiber of the delusions of grandeur puff and puff and puff up until you saw your name in the long line from Michelangelo to Matisse . . . to Hofmann himself."[7]

Hofmann had a profound impact on American art. Over half the charter members of the American Abstract Artists organization, founded in 1937, had been his students. Most major artists of the second-generation New York School—including Nell Blaine, Robert DeNiro, Helen Frankenthaler, Jane Freilicher, Michael Goldberg, Wolf Kahn, and Larry Rivers—attended Hofmann's classes, and he influenced many of the first generation as well, although less directly. Yet Hofmann's influence is far from being limited to New York. In art centers from coast to coast such as Provincetown, Minneapolis, and Berkeley, wherever his former students have settled, Hofmann's teaching is continued. In Berkeley, the presence of forty-nine paintings in the University Art Museum collection has exerted a major force on many artists who never studied directly with him. Hofmann's most important legacy resides in his remarkable ability to be provocative stylistically and philosophically decade after decade. During the 1950s Hofmann's animated surfaces

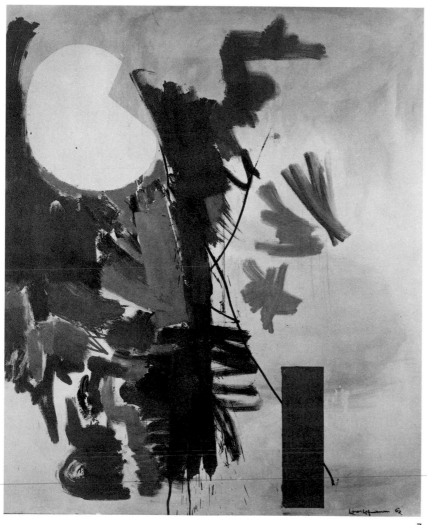

7

7. *Three Quarter Moon*, 1962
Oil on canvas, 72 x 60 in.
Mr. and Mrs. Richard Hodgson

8. *The Golden Wall*, 1961
Oil on canvas, 60 x 72¼ in.
Art Institute of Chicago; Mr. and Mrs. Frank G. Logan Art Institute Medal and Prize

9. *Tormented Bull*, 1961
Oil on canvas, 60⅛ x 84¼ in.
University Art Museum, University of California, Berkeley; Gift of the artist

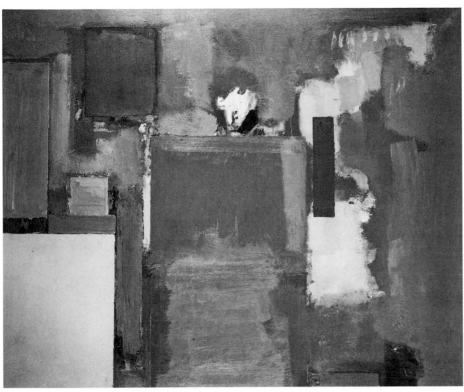

8

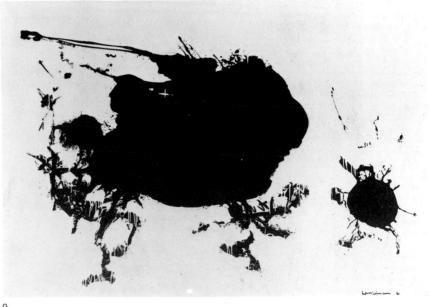

9

directed many artists to the exploration of texture. His longtime interest in using large areas of intensely saturated color proved seminal for color-field painting, a connection that may have contributed to the revival of Hofmann's reputation throughout the 1960s. Today, with the current infatuation with expressionism and the consequent attraction to heavily encrusted surfaces, as well as the cultivation of pluralism and the idiosyncratic in art, Hofmann's canvases have assumed a renewed relevance.

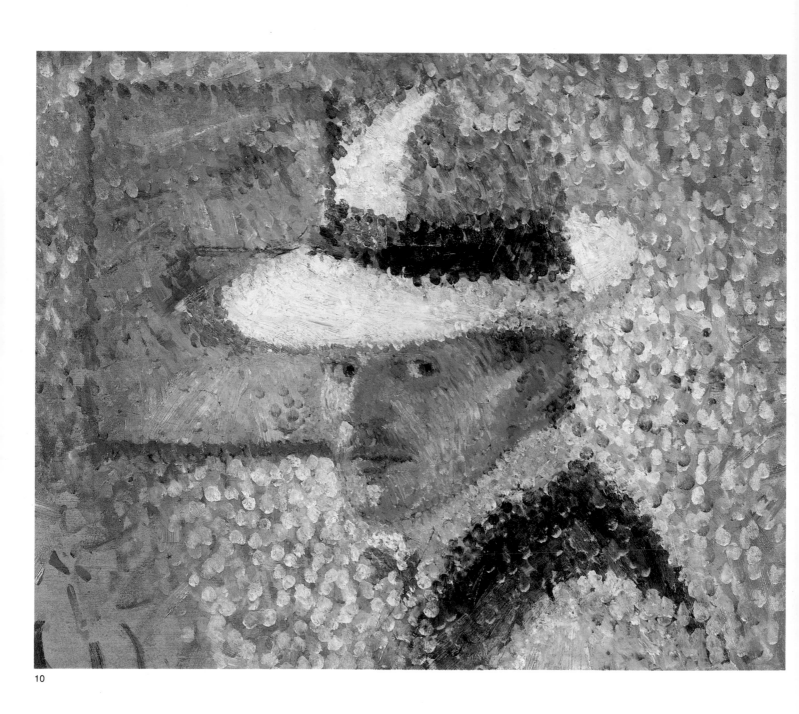

10

1 European Heritage

On March 21, 1880, Johann Georg Albert Hofmann was born to Theodor and Franciska Manger Hofmann, both of Protestant origin, in Weissenberg, Germany. Six years later, his father was awarded a minor bureaucratic position in the government, and the family moved to Munich. Hans, as the handsome young Hofmann became known, excelled in science, mathematics, and music. As the soloist in a boys' choir he sang before the Kaiser and other heads of government, already developing the impressive performance skills that later contributed to his charismatic teaching style. He also began drawing at an early age, during visits to his maternal grandparents' farm in the Bavarian countryside.

From age sixteen to eighteen, Hofmann worked for the Director of Public Works of the State of Bavaria. This department was primarily concerned with engineering and architectural projects, and Hofmann applied the technical information he absorbed there to several precocious inventions of his own, including an electromagnetic comptometer. Despite these accomplishments, Hofmann had no desire to become a scientist and, much to his parents' chagrin, he enrolled in Moritz Heymann's art school in 1898. Nevertheless, he continued to profess allegiance to science as well as to art, and he often stressed the interrelationship of the two: "All productivity finds realization simultaneously in an artistic and scientific basis. For that reason in the end, creative science is art and creative art is science."[8]

In the great museums of Munich, Hofmann discovered Rembrandt and Rubens, who remained important to him throughout his life. He later recalled the powerful impression made on him as a boy of ten by Titian's *Flagellation of Christ* in the Alte Pinakothek.[9] Munich during the last decade of the nineteenth century was a city of extraordinary vitality. Wassily Kandinsky, Rainer Maria Rilke, Frank Wedekind, and Thomas Mann were among the many distinguished residents of the artists' district called Schwabing, which Kandinsky later eulogized as "a spiritual island in the great world. . . . Everyone painted—or wrote poems, or made music, or took up dancing. In every house one found at least two ateliers under one roof."[10] The Secession Gallery was actively promoting native talents such as Lovis Corinth and Hans von Marées, whose

10. *Self-Portrait*, 1902 (recto of plate 12)
Oil on composition board, 16½ x 20¼ in.
André Emmerich Gallery, New York

15

work Hofmann especially admired, as well as exhibiting French Impressionist and Post-Impressionist painting. In this stimulating atmosphere Hofmann became as comfortable with the achievements of the modern masters as with the old, and he was as likely to borrow a theme from Picasso as from Botticelli.

Only two paintings from Hofmann's early years in Munich were later brought to the United States and thus saved from certain destruction during World War II: an oil *Portrait of the Artist's Wife* (1901) and a double-sided *Self-Portrait* and still life (1902), painted in a pointillist manner that foretold Hofmann's predilection for the School of Paris. A comparison of the two portraits shows how quickly Hofmann passed through the influences that were affecting his contemporaries. His transition from the sober School of Munich portrait style, with which he painted the woman he would later marry, to the Impressionist palette of his own self-portrait was encouraged by his first teacher of consequence, Willi Schwarz, and by the work he saw at the annual Secession exhibitions.

The names of Hofmann's other teachers—Michaelow, Aspe,

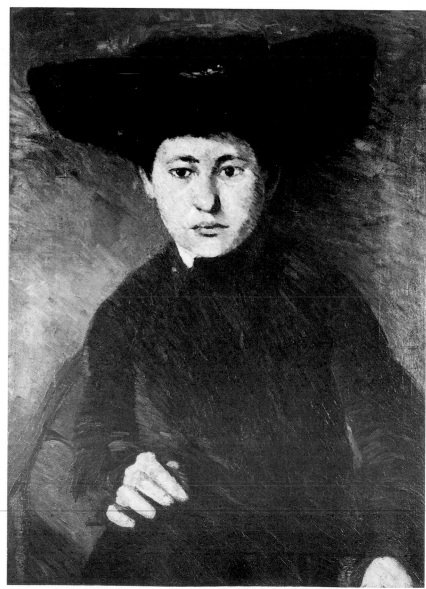

11

12

11. *Portrait of the Artist's Wife*, 1901
Oil on canvas, 27⅛ x 19⅛ in.
André Emmerich Gallery, New York

12. *Untitled (Still Life)*, 1902 (verso of plate 10)
Oil on composition board, 16½ x 20¼ in.
André Emmerich Gallery, New York

Ferenzi, and Grimwald[11]—are so little known today that not even their first names are recorded. It was Schwarz, the last in his succession of teachers, who was most instrumental in launching Hofmann's career. Not only did Schwarz acquaint Hofmann with the latest developments in French painting, but he also introduced him to Phillip Freudenberg, the son of a wealthy department store owner from Berlin. It was Freudenberg's financial support that enabled Hofmann and Maria (Miz) Wolfegg, who was to become his wife in 1929, to live in Paris from 1904 to 1914. In return for his support, Hofmann gave Freudenberg paintings as well as acted as his guide on his yearly trips to Paris. Hofmann and Wolfegg lived first in Montparnasse on the rue Campagne Première and later on the rue de Sèvres; each summer they returned to Germany.[12]

During Hofmann's ten years in Paris the most pervasive presence

in the Parisian art world was Paul Cézanne, who was to become a lifelong model for Hofmann's theorizing as well as for his painting. The explosively colored compositions of Henri Matisse, André Derain, Maurice de Vlaminck, and the other Fauves incited great controversy at the 1905 salon. In 1907 Cubism brashly emerged with Picasso's *Demoiselles d'Avignon*. The activities of the Italian Futurists also created a furor in the Parisian art world; their first manifesto, which proclaimed the automobile "more beautiful than the *Victory of Samothrace*," was published on the front page of the Paris newspaper *Le Figaro* in 1909.

Hofmann became acquainted with many of the leaders of the modern art movements. Among those whom he most likely met in the numerous nights he spent at the now legendary Café du Dôme were Pablo Picasso, Georges Braque, Georges Rouault, Jules Pascin, Fernand Léger, and Francis Picabia. He said that he and Henri Matisse also attended the same sketching class at the Ecole de la Grande Chaumière. The artist fondly recalled his years in Paris as a period when he had "been an intimate and integral part in the revolutionary changes that took place throughout this time in the entire field of the visual arts."[13] Hofmann's possibly exaggerated account, however, is not echoed in any of the annals of this time; the only firsthand record of his participation in the Paris art world is Fernande Olivier's memoirs, written about her life with Picasso. She does recount meeting the Hofmanns at the home of the German painter and art dealer Richard Goetz, whose lavish parties attracted such artists as Picasso, Braque, and Derain, as well as the dealer Wilhelm Uhde.[14] Uhde, with whom Miz Wolfegg stayed in touch until leaving for the United States in 1939, was briefly married to Sonia Delaunay. Two of Hofmann's students, Fritz Bultman and Lillian Kiesler, remember Hofmann's telling them that he and Robert Delaunay had designed textiles together for Sonia Delaunay's extravagant costumes.[15] It was during the years Hofmann was in Paris that Robert Delaunay made his most radical innovations on the somber planes of Analytic Cubism, proclaiming "Color is 'form and subject.'"[16] Hofmann similarly announced: "Form only exists through color and color only exists through form."[17]

Unfortunately, all of the work that Hofmann did in Paris was either destroyed or scattered by the war, and virtually our only knowledge about it comes from the artist's memories and those of his students and friends. Vaclav Vytlacil, for one, recalls the drawings that Hofmann had made in Paris as early Cubist attempts in which his teacher had been trying "to get away from the tricks of light and shade into form."[18] Frederick Wight's essay for the catalog of Hofmann's 1957 exhibition at the Whitney Museum of American Art in New York, which he based on his conversations with the artist, records that Hofmann had painted still lifes, figures, and landscapes in the Luxembourg Gardens. Emile Szittya, in his account of German painters in France, mentions Hofmann only as a "reserved worker" (*un travailleur réservé*), who belonged to the circle of Picasso, Braque, and Derain.[19]

Although Hofmann's painting doctrine was a personal amalgam of many different aesthetics, it was firmly rooted in Cubist theory

13. Diagram of Rembrandt's *Queen Artemisia* (from Hans Hofmann's "Creation in Form and Color: A Textbook for Instruction in Art," 1931)

14. *Untitled (St. Tropez Landscape)*, 1928 India ink on paper, 9¾ x 13⅛ in. André Emmerich Gallery, New York

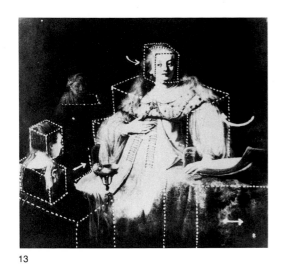

13

and in the principles of Cézanne that provided the foundation of Cubism. In "Creation in Form and Color: A Textbook for Instruction in Art," Hofmann's major treatise on painting, he quotes Cézanne's famous statement that "In nature you see everything that is in perspective in relation to the cylinder, the sphere, and the cone in such a way that each side—each surface of the object— moves into depth in relation to a central point," and Hofmann credits it as "the starting point for an entirely new conceptual orientation in painting." Hofmann's concern with transparency, overlapping, and the possibility of portraying multiple views of an object in one painting all stem from Cubism.[20] Hofmann frequently illustrated his ideas by marking up reproductions of Old Master paintings. His diagram on *Queen Artemesia* by Rembrandt in "Creation in Form and Color" exemplifies his Cézannesque interpretation of the volumes of the body as a series of planes.

Although Hofmann's connection to French art traditions and innovations has been most heavily emphasized over the years, he was also aware of such contemporary developments in his native Germany as the formation of Die Brücke ("The Bridge") in Dresden in 1905 and the organization of Der Blaue Reiter ("The Blue Rider") in Munich in 1911. Beginning in 1899, the Berlin Secession organized annual exhibitions, at first intended to promote only German work but soon encompassing French art as well. A painting by Hofmann listed simply as *Akt* ("Nude") was included in the 1908 Secession exhibition along with graphic work by

13

14

15

members of Die Brücke as well as paintings by Max Beckmann, Pierre Bonnard, Cézanne, Lovis Corinth, Wilhelm Leibl, Max Liebermann, Edouard Vuillard, and many others. Hofmann was represented at the Secession show the following year with an entry called *Damenbildnis* ("Portrait of a Woman"). In 1910 Paul Cassirer presented Hofmann's first major exhibition at his prestigious gallery in Berlin, where paintings by Oscar Kokoschka were also on display. A brief but telling review in the German periodical *Kunst für Alle* aligned Hofmann with the artists of the School of Paris, an allegiance he was long to maintain.

The outbreak of World War I caught Hofmann and Wolfegg summering on the German Ammersee and kept them from returning to Paris. The examples of Hofmann's work that survive from this period include several bright expressionist landscapes of the Ammersee, which recall Kandinsky's early scenes of Murnau; a few descriptive cityscapes similar to those that Oskar Kokoschka was painting about 1910; and a gently colored ceiling design executed in 1914 in collage, watercolor, and pencil, which depicts a group of female nudes, presumably for a commission.

Hofmann was exempted from military service because of a lung affliction. Having lost the support of his patron, in 1915 he opened the Hans Hofmann School for Modern Art, at 40 Georgenstrasse in Schwabing. Among the six or seven students in the first class he taught was Eva Lichtenstein Freyer, who had switched from the Royal Bavarian Academy of the Plastic Arts to Hofmann's school upon the recommendation of her landlady, a friend of Hofmann's. (Freyer wanted to study with a male teacher, and all the men at the Academy had left to enlist.) Freyer's recollections of her immaculately dressed teacher, who identified himself as an "expressionist" and attracted students eager to learn the principles of

15. *Untitled (Landscape)*, 1914
Watercolor on paper, 8 x 10⅜ in.
André Emmerich Gallery, New York

16. *Untitled*, 1930
Ink and collage on paper, 13⅝ x 12¼ in.
Private collection

modern art, constitute one of the few firsthand accounts of Hofmann in Munich before the early 1920s.[21]

Hofmann told a number of friends that he had stored many of the canvases that Kandinsky had been forced to leave behind when that artist had to flee Germany during World War I. Nevertheless, it seems that Hofmann and Kandinsky never met and that this arrangement came about through the friendship of Gabriele Münter (Kandinsky's companion) and Miz Hofmann. On various occasions Hofmann told visitors that either one or both of the Kandinsky paintings in his New York apartment had been given to him by Münter in appreciation of his assistance. Although the friendship between Miz and Münter is a certainty, no documentation has yet been found to confirm Hofmann's story.[22] Nevertheless, both Hofmann's writings and paintings do attest to his early familiarity with Kandinsky's work. Among the annotated volumes in Hofmann's Munich library were a copy of the *The Blue Rider* almanac (1912), coedited by Kandinsky and Franz Marc, and a copy of Kandinsky's *Concerning the Spiritual in Art* (1913).

Belief in the spiritual nature of art was one of the many ideas that Hofmann shared with Kandinsky. Among others were the

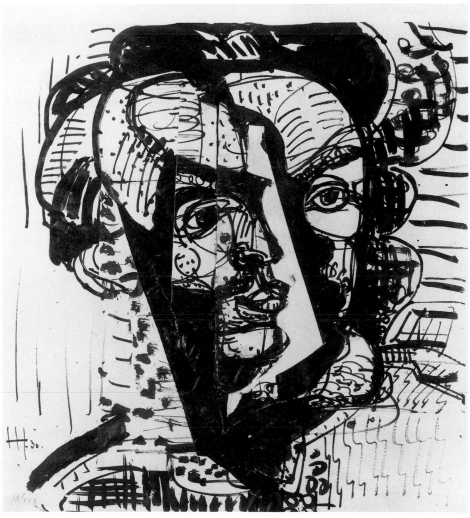

16

relationship of art and music, the role of intuition in artistic creation, and the participation of all the senses, not just the eyes, in making and responding to art. Among Hofmann's other German sources was Wilhelm Worringer, whose *Abstraction and Empathy*, a defense of abstraction, was published in Munich in 1908. Worringer's book, one of the primary expositions of expressionist aesthetics, popularized the concept of empathy, which is so central to Hofmann's philosophy. Adolf von Hildebrand, a sculptor and author of *The Problem of Form in Painting and Sculpture* (1893), a volume read by all of Hofmann's students in Munich, was another early influence on his thinking. But of all the names he invoked, it was Johann Wolfgang von Goethe that Hofmann cited most frequently, both in conversation and in writing. Goethe's quasi-mystical, quasi-rational philosophies of color are a curious blend of Germanic sources based equally on scientific knowledge and on the spiritual power of artistic creation, from which Hofmann, too, drew inspiration.

There is no evidence that Hofmann either painted or drew during his early years as a teacher in Munich; the burdensome responsibilities of running the school seem to have monopolized his time. According to Glenn Wessels, who studied with Hofmann during the late 1920s, the fact that Hofmann produced little art may also be attributed largely to the shock of the war and his sense of the futility of painting.[23] It also seems that Hofmann had trouble reconciling his roles as teacher and painter from the beginning.

After the war Hofmann's international reputation grew, and the school enlarged significantly as numerous Americans and Europeans enrolled, including Clarence Carter, Carl Holty, Alfred Jensen, Louise Nevelson, Ludwig Sander, and Vaclav Vytlacil. Vytlacil has recalled the "small, dingy, and poverty-ridden single studio" where classes were conducted when he first began studying with Hofmann in 1922.[24] The only furnishings were a model's stand and a pot-bellied stove. Hofmann's prowess as an instructor was undiminished by the stark surroundings, and Vytlacil has also described Hofmann's impressive ability to explain the complexities of post-Cézanne development so that "those who were innocent could be made to understand."[25]

In 1918 Hofmann started conducting summer sessions in picturesque areas in the Alps as well as in Ragusa, Capri, and St. Tropez—locations chosen as much for the beauty of the terrain as for the inexpensive cost of living there off-season. By the mid-1920s, in order to accommodate the increased enrollment in his winter classes, Hofmann had to rent an additional room above the original studio, using one space for drawing and the other for painting classes. Nevertheless, conditions at the school continued to be fairly bleak through the late 1920s. In exchange for free tuition, Glenn Wessels tutored Hofmann in English at six every morning before classes began, and he remembered vividly the cold mornings when the shortage of fuel made them huddle for warmth in the draperies used for still-life arrangements.[26]

Although Hofmann was painting only rarely, he began to draw copiously. Among his subjects were portraits, figure studies, and, during the summer, landscapes. Some of these drawings were in

17. Hans Hofmann and Miz with (from left) Tristan Forster, John Haley, and Joan Hein in the Alps, c. 1928

18. *Green Bottle*, 1921
Oil on canvas, 17¾ x 22¾ in.
Museum of Fine Arts, Boston; Gift of William H. and Saundra B. Lane

17

22

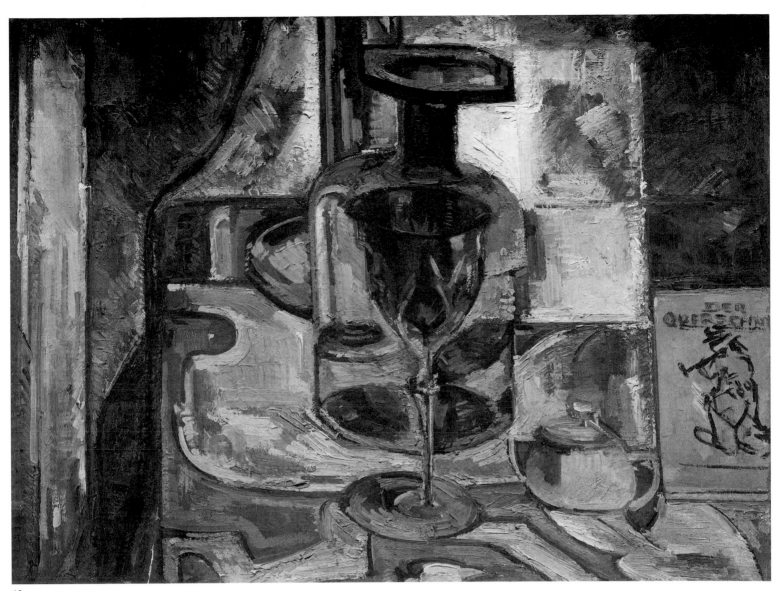

18

pencil or charcoal; others were executed rapidly with a matchstick dipped in ink. Even later, when he was painting regularly again, Hofmann often made numerous drawings before tackling a problem in paint, a process he felt was essential "to become absolutely sovereign in painting."[27] In one of his few attempts at print-making, Hofmann had a group of about fifteen portraits and figure studies reproduced as *lichtdrucke*, a photographic process similar to the photograms of Man Ray and Laszlo Moholy-Nagy. Of the few oil paintings Hofmann made between 1915 and 1930, only one is still known to exist, a small still life called *Green Bottle* 18 (1921), which incorporates a section from the German periodical *Der Querrschnitt*, in the tradition of Cubist collage. Even the scant number of early works that have survived exemplify Hofmann's striking ability to combine and transform inspirations from various art traditions, an ability that was to continue throughout his career.

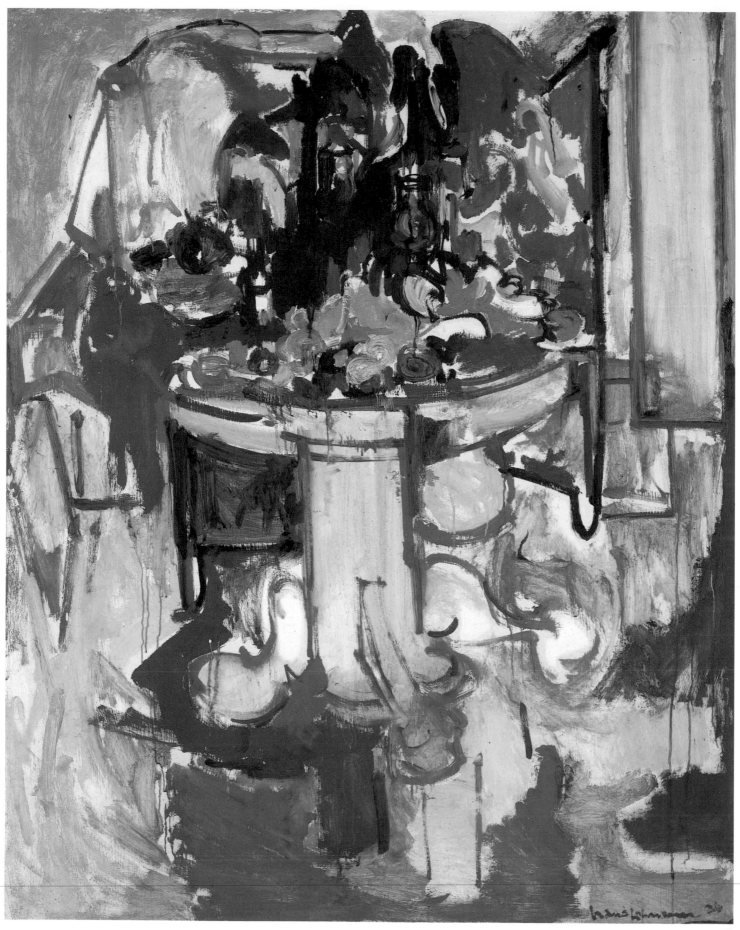

California, New York, Provincetown

Hofmann continued teaching year round at his Munich school until his former student Worth Ryder asked him to be a guest professor at the University of California at Berkeley for the summer session of 1930. Ryder had been making arrangements for Hofmann to come to Berkeley since returning from Hofmann's school several years before.[28] The fact that Vaclav Vytlacil had already "spread the Hofmann gospel"[29] while teaching at Berkeley in 1928 and 1929 made Ryder's task easier.

Hofmann welcomed this opportunity to escape, if only for a summer, the growing political turmoil in Europe, where academic institutions were suffering from the oppressive atmosphere. He repeatedly expressed his appreciation for this offer of refuge: "If I had not been rescued by America, I would have lost my chance as a painter."[30] His lifelong gratitude for the invitation to teach at Berkeley was the impetus for his gift to the University of California of the forty-five paintings that form the core of the Hans and Maria Hofmann Collection in the University Art Museum on the Berkeley campus as well as an endowment to maintain them.

Glenn Wessels accompanied Hofmann on the boat to the United States and traveled with him across the country, stopping to visit former students along the way. Hofmann relied heavily on Wessels as his translator. Even at the end of his life, after more than thirty-five years in America, Hofmann's heavy accent and his habit of peppering conversations with German phrases (most frequently "nicht war," or "isn't it so") kept many an anxious student from achieving enlightenment. Conversations with Hofmann were also made difficult by his loss of hearing which, according to some accounts, was the result of a brawl in Paris. As he grew older, he increasingly relied on a hearing aid, and many students and friends remember how frustrating it was to try to make themselves understood on days when Hofmann either forgot to turn his hearing aid on or chose not to. For others, such as Robert Motherwell, "His broken English and hearing problem . . . only enhanced his authority. Because he was difficult to understand, you couldn't doubt or challenge him. It gave him an invulnerability—he came on like an old Greek god, a Poseidon or a Zeus."[31]

19. *Table with Fruit and Coffeepot*, 1936
Casein and oil on plywood, 60⅛ x 48⅛ in.
University Art Museum, University of
California, Berkeley; Gift of the artist

20

Hofmann was enthusiastically received at Berkeley, and he agreed to teach an additional six-week course, from August 11 to September 30, to accommodate the many students who had been turned away from his overcrowded first session. He returned to Munich for the winter but came to Berkeley again in the summer of 1931. In addition to teaching that year, he completed the first version of "Creation in Form and Color: A Textbook for Instruction in Art." He had begun formulating the ideas in this still-unpublished manuscript when he opened his first school in Munich sixteen years earlier.[32] He wrote a second version in 1934, completed a third in 1948, and then continued to expand on the central themes in this text until the end of his life.

Also in 1931 Hofmann was given his first exhibitions in America: in July at the Berkeley Art Department in Haviland Hall, and in August at the California Palace of the Legion of Honor in San Francisco. The titles of the sixty-six drawings on display in the latter exhibition—some English, some French, some German—reflect the different locations where he had recently taught and worked. Among these drawings were portraits and figure studies from his previous winters in Munich, scenes of St. Tropez from either the summer of 1927 or 1928 when the school met for the

summer on the French Riviera, and views of the northern California countryside.

The second summer that Hofmann was away, his wife hired Edmund Daniel Kitzinger to conduct the summer program in Murnau in order to maintain the enrollment of the school. The sisters Ruth and Helen Hoffman, who had previously studied with Hofmann in St. Tropez, described how unpleasantly the school atmosphere had changed when they arrived in Murnau in 1931. Since the Germans suppressed all controversial news, the American students had not known how ominous the political situation was, and their own newspapers and magazines reporting current events were confiscated when they crossed the border into Germany. Furthermore, to the Hoffmans' surprise, no one wanted to hear about Hitler, since "the school was afraid it would lose its permit if the students were too interested in what was happening. We were there to paint, and to paint only unobjectionable things. At the end of the season, when the exhibition of students' work was about to take place, the professor was given his instructions by higher-ups to exhibit no works of 'degenerate modern art.'"[33] Their account more than explains Hofmann's reluctance to return to Europe. Nevertheless, like many Europeans the Hofmanns believed that Hitler would be only a fleeting phenomenon, and Mrs. Hofmann remained in Europe for a number of years after her husband's departure, trying to keep the school going until he returned.

In the autumn of 1932 Hofmann was invited to join the faculty of the Art Students League in New York City, and he moved to New York, where he lived in the Barbizon Plaza Hotel. Once again, Vaclav Vytlacil had proselytized the theories of his former teacher in his own lectures so that when Hofmann's courses were

20. *Untitled (Studio Still Life)*, c. 1933
India ink on paper, 10¾ x 8¼ in.
Private collection, Cincinnati

21. *Untitled (California Oil Fields)*, 1930
India ink on paper, 8⁷⁄₁₆ x 10¹⁵⁄₁₆ in.
André Emmerich Gallery, New York

21

announced, students were eager to study with him. Burgoyne Diller, Rae Eames, George McNeil, Lillian Kiesler, Mercedes Carles Matter, Louise Nevelson, and Irene Rice Pereira were among those who filled his first classes. Hofmann's modernism was a welcome relief from the dreary Regionalism being offered by other teachers at the league, such as Thomas Hart Benton.

Hofmann left the Art Students League in 1933 to found his own school. Classes were initially held in a studio at 444 Madison Avenue, then the Hans Hofmann School of Fine Arts opened at 137 East Fifty-seventh Street; finally, after another move to 52 West Ninth Street in 1936, the school settled in 1938 at its permanent location on the third floor of a notable building at 52 West Eighth Street in Greenwich Village (designed by architect Frederick Kiesler in 1929). The basic class schedule remained the same in the New York school from the beginning. There were three sessions each day—morning, afternoon, and evening—and a student could enroll in one or all three sessions for as little as one week at a time. (Enrollment in all three sessions cost forty-five dollars a month.) In the morning and evening, students drew from the live model. The afternoon class was designated as a still-life class, although still-life arrangements were always set up, as they had been in Munich, and students could work on them at other times as well. Most students drew with charcoal, but they could use any material they chose; some preferred brush or pen and ink, crayon, pencil, collage, pastel, or paint. Hofmann usually attended class two days a week. Classroom monitors opened and closed the school, called roll, and attended the models. (At various times this coveted position was filled by George McNeil, Lillian Kiesler, Robert DeNiro, Wolf Kahn, and Red Grooms, in exchange for tuition.) On Friday, the day designated for formal criticism by Hofmann, each student presented work before the entire group. On his other day in class, Hofmann would walk around the room, occasionally reworking a student's composition as the class observed.

Lillian Kiesler remembers that Hofmann was painting in watercolor as early as 1932 in a studio somewhere in the west twenties in New York; this workspace was located on the top floor of an office building, which was accessible only by stairs at the top of the elevator shaft. A small still life of a flower in a pot as well as a lavish bouquet of flowers on a chair are among the works that he painted there. *Apples*, also painted in this studio about 1932, is one of the earliest paintings in oil that Hofmann made in the United States. The way he applied the paint to this picture in small dabs demonstrates how important Impressionism continued to be for him, while the composition testifies to the continuing influence of Cézanne.

According to Mercedes Carles Matter, Hofmann began painting in earnest again at her encouragement during the summer of 1934, when she was one of his students at the school of his former Munich student Ernest Thurn, in Gloucester, Massachusetts. That summer Hofmann shared a house with Mercedes and her father, the painter Arthur B. Carles, whom he had first met in Paris about 1904.[34] When Mercedes had begun studying with Hofmann at the

22

22

Art Students League in 1932 she reunited the two men, and a little-known but intriguing friendship developed between them. Hofmann's admiration for Carles, whom he lauded as America's "finest painter,"[35] was to continue until the end of his life, when he dedicated the magnificent *Memoria in Aeternae* (1962) to Carles as well as to Arshile Gorky, Bradley Walker Tomlin, and Jackson Pollock.

After taking over Thurn's school for two summers, in 1935 Hofmann opened a school in Provincetown, Massachusetts, where he became the nucleus of a large community of artists on Cape Cod, many of whom were not directly associated with his school. Artists and other visitors from all over the Cape congregated on Fridays to watch his theatrical critiques. The Provincetown school was originally located in a barnlike structure on the property of a large frame house that the Hofmanns rented on Miller Hill Road, overlooking Provincetown Bay. This "house on the hill," the subject of many of Hofmann's paintings and drawings, had formerly [32] belonged to the noted painter and teacher Charles Hawthorne. Enrollment for the entire twelve-week summer session cost one hundred ten dollars, and the Hofmanns rented rooms to students

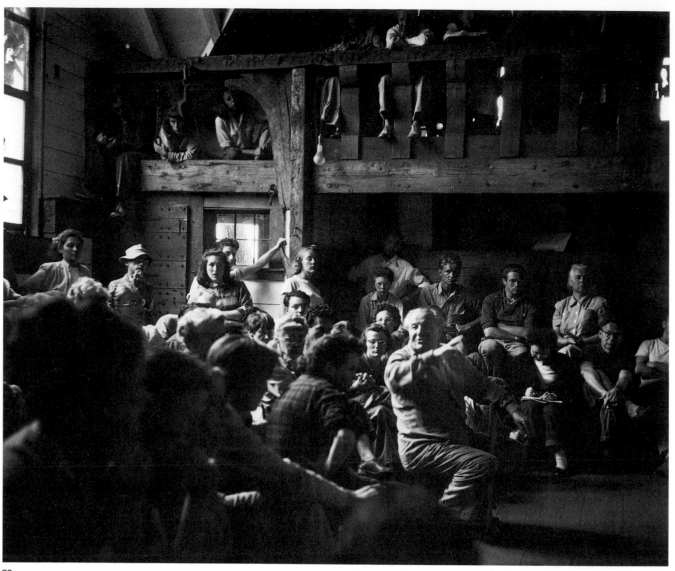

23

for between fifty and seventy-five dollars for the season, depending on the size.

In 1945 the Hofmanns bought a large house on Commercial Street in the east end of town and relocated the school to a studio that had been built adjacent to the house by the marine painter Frederick Waugh. The purchase of this house was made possible largely through the generosity of publishing heiress Helen Donnelly. (Also an intimate of Frank Lloyd Wright, Donnelly proposed to Hofmann that he relocate his winter classes to Wright's Taliesin West one year when the architect planned to be away.) Until 1958, when the school closed, Hofmann painted in a modest studio at Day's Lumberyard on Pearl Street, where a number of his students also had studios. Hofmann conscientiously maintained a rigorous schedule. He arrived at Day's each morning at 5:00 (Lillian Orlowsky, who lived in an adjoining studio, always knew when he arrived, because the locally made sandals he wore in Provincetown made a squeaking noise on the wooden floor). Hofmann wrote until daylight and then painted until 10:00, when he returned home to teach. After classes were over, he went once again to his studio to paint.

24

23. Hans Hofmann teaching in Provincetown, 1948

24. The catwalk of Day's Lumberyard, Provincetown, 1940s, with (from left) Peter Grippe, Sam Kootz, Fritz Bultman, and Hans Hofmann.
Photograph by Maurice Berezov.
Provincetown Art Association and Museum

As late as the spring of 1938 Hofmann was planning to take a group of students on a tour of France and Italy, followed by three weeks of classes in Capri. The only hint that Hofmann considered the current political events in Europe as being at all threatening appears in a note on the announcement of this tour, that "should conditions beyond the school's control warrant a postponement of the tour, the summer school will be held as usual in Provincetown, Massachusetts," as it was. Amazingly, even the announcement in the May 1938 issue of *Art Digest* that the Hofmann School would meet in Provincetown rather than in Europe still optimistically said that the European tour was simply "postponed for one year."

It was about the time that the European trip was canceled that Miz Hofmann finally despaired of their ever resuming their previous existence in Munich, and it became clear that her only option was to join Hofmann in the United States. Fortunately, Fritz Bultman and his family made the complicated arrangements for her passage to America, and Miz finally arrived in New York in 1939, on one of the last boats to reach the United States before the war erupted. She brought only a few of their possessions: some of her husband's work; paintings by Georges Braque, Fernand Léger, Joan Miró, Louis Marcoussis; some pieces of Biedermeier furniture; and her extensive collection of canvases by the French primitive master Louis Vivin.[36] Most of their belongings were left behind because she was still certain that they would eventually return to Munich.

After a rather difficult period of adjustment, Miz and Hans grew close again and moved into an apartment together on Fourteenth Street. Miz became increasingly involved in all aspects of her husband's career, making sure that his pictures were framed, arranging to have potential buyers and dealers see his work, and overseeing activities at the school. In sharp contrast to his classroom bravura, Hofmann, who came from a relatively simple background, was not always comfortable in social situations, a difficulty compounded by his hearing disability. Intensely private, he rarely let anyone except Miz in his studio, where he painted in the nude. Miz was much more outgoing by nature, and it was she who established and nurtured all his professional and social ties. Rarely has anyone who knew the Hofmanns talked about Miz without mentioning the graciousness and warmth with which she entertained. Helen Frankenthaler, who studied briefly with Hofmann in the summer of 1950 and remained his close friend, still recalls with amazement Miz's seemingly miraculous ability to prepare and serve exquisite dinners even under penurious circumstances. Without a proper kitchen, she improvised skillfully, having only a two-burner stove on which to cook.[37]

Miz devoted herself to producing and maintaining the proper creative environment for her husband. In their New York apartment as well as in their Provincetown home, she painted not only the furniture but also the floors and walls with the same Rembrandt green, cobalt blues, and cadmium reds and oranges that her husband used in his paintings. According to a letter that Hofmann wrote in the summer of 1940, Miz's plans were to create first "a Matisse room, the next will be a Mondrian room, and so on in the summers to come."[38] The bright rooms not only provided a setting for

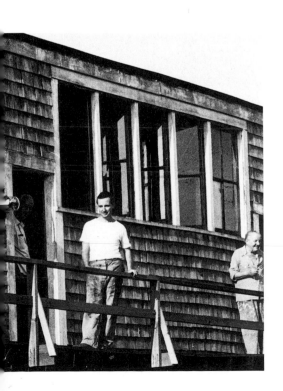

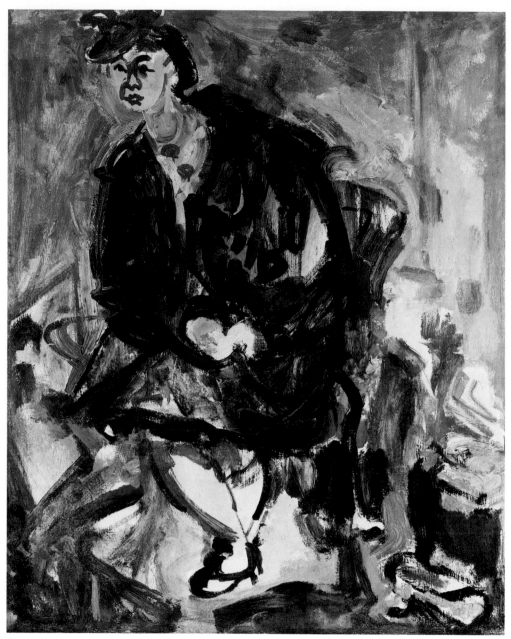

25

Hofmann's own paintings but also paid homage to the modern masters he most admired. Hofmann's paintings were an extension of his everyday life and the surroundings in which he lived.

The subjects that Hofmann painted until the mid-1940s can be classified into three principal categories: portraits and figure studies, landscapes, and interiors and still lifes: the same subjects he assigned to students in his school. *Japanese Girl*, one of two portraits of this unidentified model that Hofmann is known to have made, was painted in 1935, the year from which a full documentation of his career as a painter becomes possible. Physiognomic details are spared in the interest of conveying a sense of the body's volume and weight. Other portraits of these years are recognizable portrayals of their subjects, such as Alice Hodges, Lillian Kiesler, and Mercedes Carles Matter—close associates of Hofmann and his

25. *Japanese Girl*, 1935
Casein and oil on plywood, 43⅜ x 38⅜ in.
University Art Museum, University of California, Berkeley; Gift of the artist

26. *Portrait of Lillian O'Linsey Kiesler and Alice Hodges*, 1938
Oil on plywood, 45 x 60 in.
André Emmerich Gallery, New York

school. Throughout his life Hofmann attracted women of strong personality, beauty, and great charm, who championed him enthusiastically. Some became his patrons; others, such as Lillian Kiesler and Alice Hodges, worked for years as unpaid administrators of the school.

Hofmann also painted and drew a number of self-portraits, generally depicting himself at work. Most of these are intimate in scale, although at times the format may be larger, as in *Self-Portrait with Brushes* (1942), and the depiction more whimsical, as in *Self-Portrait, the King* (1942). Two self-portraits that were previously the recto and verso of one plywood panel capture their subject in different moods. In *Self-Portrait I* (1942) the artist confronts the viewer with a forthright stare; in *Self-Portrait II* (1942) his averted eyes and tilted head convey a sense of introspection. The features of both portraits, which are standard in countless of Hofmann's depictions of himself, are drawn in bold black lines, with the broad nose delineated by a triangular plane and the tousled hair suggested by a cluster of wispy lines. In an unusual gesture, Hofmann signed and dated *Self-Portrait II* across

26

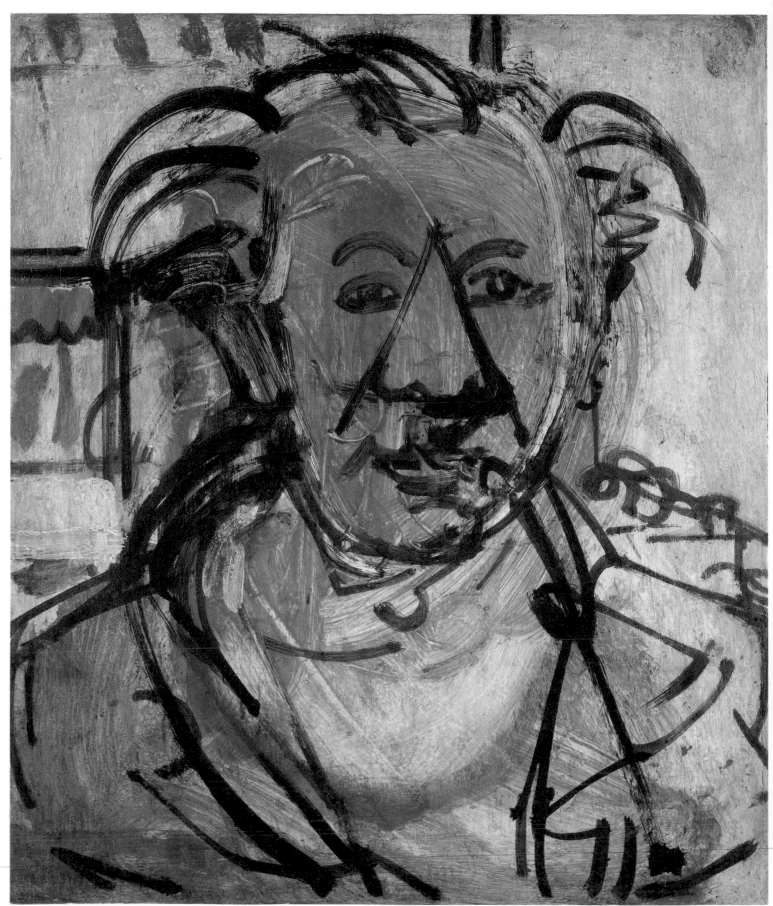

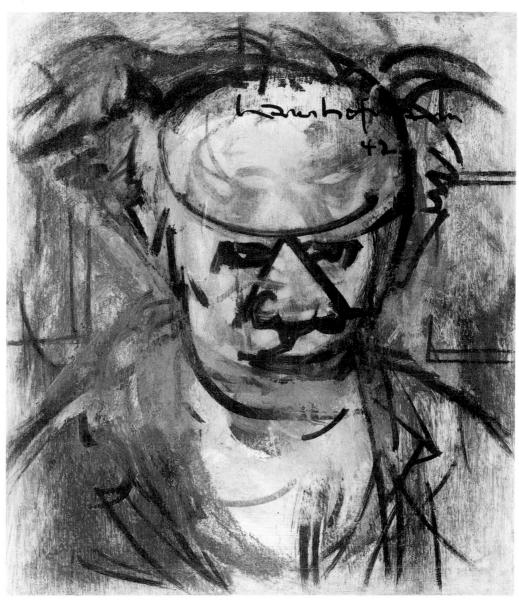

28

the top of his forehead. The caricaturist Quentin Fiore has recalled
how Hofmann encouraged students to see the potential for carica-
ture in the human anatomy.[39] These two self-portraits convey
this potential.

From the mid-1930s through the mid-1940s, Hofmann painted
a number of interior scenes depicting the objects in his home and
studio. These interiors were painted first in a space he shared with
his student Wilfred Zogbaum on Ninth Street and later in his own
studio on Eighth Street. The opulently laden table featured in
Table with Fruit and Coffeepot (1936) appears frequently in
Hofmann's interior scenes—sometimes painted yellow, as here and
in *Yellow Table on Yellow Background* (1936); at other times
pink, as in *Still Life—Pink Table* (1936); or blue, as in *Green Vase
on Blue* (1940). In spite of such brilliant depictions, the actual
piece of furniture, originally in his studio in New York and later

19

moved to Provincetown, was an unpainted oak table, which Hofmann transformed on canvas according to the requirements of each composition. For that matter, all the furniture he depicted remained unpainted until Miz's arrival.

The lively Fauvist palette of *Table with Fruit and Coffeepot* is typical of the numerous interiors and landscapes that Hofmann painted during the 1930s and '40s. Long streaks of paint drip from the bottom edges of the furniture; rather than reworking these areas or preventing the paint from running, Hofmann let these marks of his painting process become an integral part of the composition. Although more abstract than many of his interiors, this table is undeniably laden with the mounds of fruit, flowers, and assorted kitchen utensils that are, typically, positioned against a cloth backdrop. Students still marvel when they recall the in-

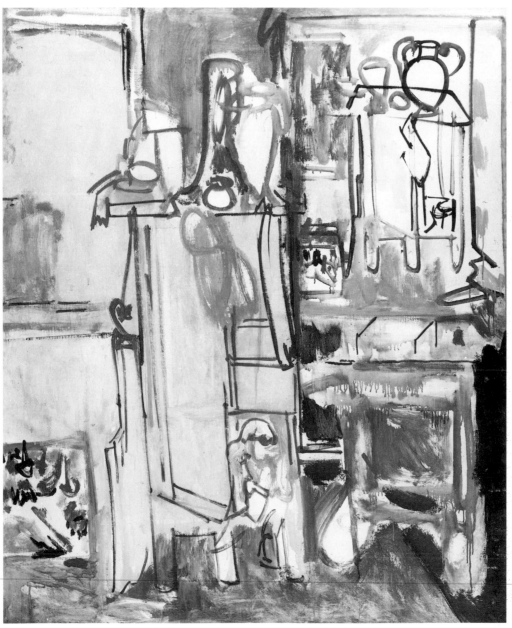

29

genious settings that Hofmann constructed for their classroom exercises, often spending an entire afternoon combining cloth, dimestore cups, playing cards, and bowls of fruit with aluminum paper and other light-reflecting surfaces to create patterns of sharp contrast. The objects in his still lifes were chosen not for their aesthetic value but for their space-making potential. According to Hofmann: "Space was never a static, inert thing, but alive, and its life can be felt in the rhythm in which everything in a visual ensemble exists."[40]

The same objects were to reappear in Hofmann's own still lifes with varying degrees of recognizability over the next twenty years. In *Fruit Bowl #1* (1949) and *Fruit Bowl* (1950), for example, the titles enable the viewer unfamiliar with Hofmann's earlier work to identify the curvilinear objects in these compositions as pieces of fruit. Other titles offer no clues to the subject matter. To discern a still life in *Orchestral Dominance in Green*, one of a series of three paintings of the same subject that Hofmann painted in different colors in 1954, one must be intimate with his previous compositions.

Hofmann often portrayed one of his own paintings in his interior scenes, as in *Table with Teakettle, Green Vase, Red Flowers* (1936). 30 In this case he propped one of his paintings of a tall yellow cupboard on the floor behind the table. In *Interior Composition* (1935), 2 *Studio Unfinished*, and *Vases on Yellow Cupboard* (both 1936), 29 Hofmann depicted this same yellow cupboard both as part of the interior that was the primary subject of each work and as an element in each "painting within a painting" as well. Hofmann also included in these canvases a sketchy version of the sailboat-filled Provincetown harbor, either as a primary subject or as the subject of the "painting within a painting," as in *Vases on Yellow Cupboard* and *Interior Composition*. Since the Renaissance the depiction of a "painting within a painting" has served various functions, from affording some cultural documentation about the time when the picture was made to providing a formal element, important only for its color, shape, and size. In the late nineteenth and early twentieth centuries Edgar Degas, Henri Matisse, and Georges Seurat incorporated examples of their own works, arranged as a caller might actually find them, in portrayals of their studios.

Matisse in particular was a lifelong source of inspiration for Hofmann, who absorbed his lessons so successfully that Greenberg claimed that in America during the 1930s one could learn more about Matisse's color from Hofmann than from Matisse himself.[41] Hofmann's incorporation of his own "paintings within paintings" might have been learned from Matisse, who used that device not only in *The Red Studio* (1911) but in *The Pink Studio* (1911) and *Large Interior in Red* (1948) as well. The spatial dislocation caused by the aggressive frontality of objects in *Table with Teakettle, Green Vase, Red Flowers* and the way the large yellow table is distinguished from the floor only by its sketchy outlines may also be attributed to the influence of Matisse, who often drenched floors, walls, and furnishings with the same hue.

During the summers from the mid-1930s until 1944 Hofmann concentrated on landscapes and made numerous drawings and

29. *Vases on Yellow Cupboard*, 1936
Oil on canvas, 51⅞ x 41⅞ in.
André Emmerich Gallery, New York

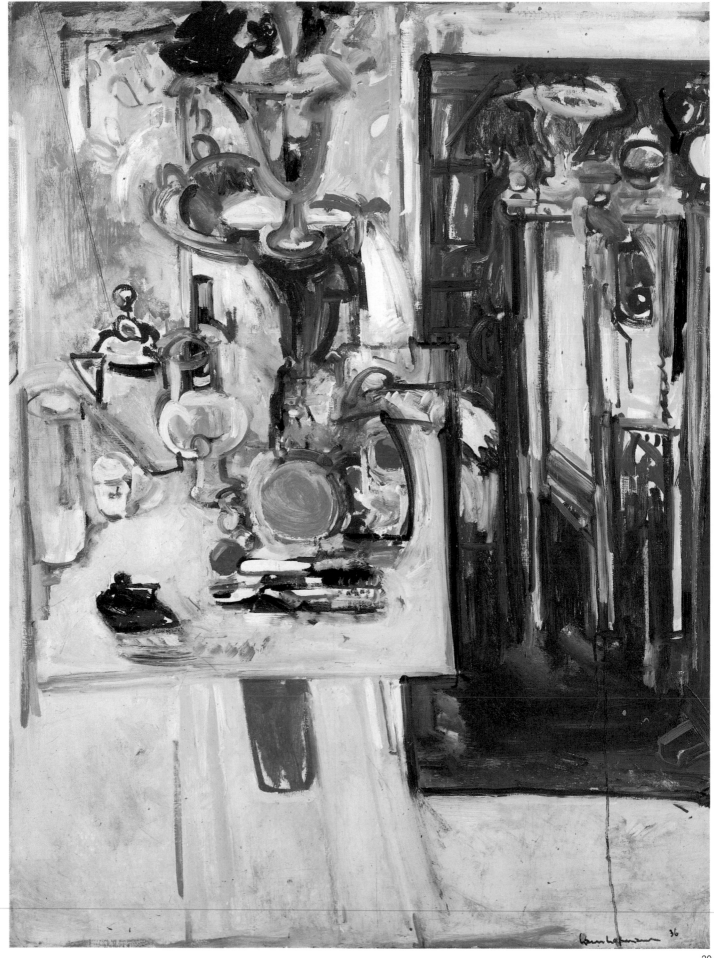

30. *Table with Teakettle, Green Vase, Red Flowers*, 1936
Oil on plywood, 54½ x 40⅜ in.
University Art Museum, University of California, Berkeley; Gift of the artist

31. *Landscape*, 1941
Oil on board, 24 x 30 in.
Private collection, Boston

32. *Provincetown Landscape*, 1942
Crayon on paper, 14 x 17 in.
Douglas Drake Gallery, Kansas City, Kansas

31

32

paintings of Cape Cod in ink, crayon, oil, and watercolor, returning to a certain spot until he felt that he had mastered the view. Often he was seen out on the beach with his easel weighted down with bottles of water and turpentine so that the wind would not blow it away. He cherished the Cape's ". . . miles of stunted pines and its wild sea country of dunes and salt marshes, of inlets, harbors, and bays, and its dramatically bleak moors."[42] As one drives down Route Six, the main road that winds from one tip of the Cape to the other, the titles of some of his paintings, such as *Pilgrim Heights* and *Pamet Roads*, flash by in the road signs and identify sites of special meaning to the artist.

The descriptive and often compactly constructed landscapes that Hofmann had drawn in Europe seem no more than preliminary exercises for the multiplicity of expansive visions that he created after he started painting again in the United States. His Cape Cod landscapes range from descriptive, almost anecdotal depictions reminiscent of those by Raoul Dufy, to seascapes that are Fauvist both in palette and in luminosity, to much more expressive scenes. In *Landscape* (1941), for example, land, sky, and water merge into swirling crests of paint. Other landscapes with only occasional recognizable elements, such as the outline of a house or the suggestion of a tree, show an affinity with those that Kandinsky painted around 1913. In still others, whole vistas dissolve into brilliant planes of color, prophetic of Hofmann's later architectonic compositions.

In August of 1940 Hofmann revealingly wrote: "Well the summer is gone . . . I wish only good weather that would enable me to paint. I paint quite wonderfully but have not accomplished what I want. So much can be said through color that I want the fullness of myself realized in what I'm doing. I wish I could be younger for the work's sake. Seeing that it takes a long time to realize oneself. But I believe my destiny will permit me to fulfill wonders."[43] From this letter emerges the image of a somewhat frustrated yet nonetheless hopeful and purposeful Hofmann, aware of his great talent as well as its underdevelopment.

Although familiarity with Hofmann's theories is not necessary to enjoy or to appreciate his work, it does enhance the experience. The following statement, which he reiterated throughout his life, expresses the most central elements of his philosophy: "Creation is dominated by three absolutely different factors: first, nature which works upon us by its laws; second, the artist who creates a spiritual contact with nature and his materials; third, the medium of expression through which the artist translates his inner world."[44] However abstract his compositions became, Hofmann always maintained nature as his point of departure.

Time and again Hofmann repeated the necessity of respecting the nature of the artist's medium. In a glossary in the back of *The Search for the Real and Other Essays*, which helps explain many of his frequently confusing terms, Hofmann defines the "medium of expression" as "the material means by which ideas and emotions are given visible form." Hofmann taught that each artist should consider from the beginning the limitations and individuality of the materials he is using. Because the picture surface is flat, the

artist must always keep in mind that different laws operate in a picture than in the natural world. In the process of translating three dimensions into two, the artist's challenge is to create the greatest illusion of volume possible while maintaining the integrity of the two-dimensional surface. In the simplest terms, what Hofmann wanted to achieve was the maximum sense of volume and depth possible on the flat picture plane. It was this animation of the picture surface that made a work "plastic," the goal of Hofmann's instruction as well as of his painting.

For Hofmann, the translation of three-dimensional reality into the two dimensions of the picture plane was a spiritual process. This concept of spirituality, which was rooted in the German metaphysical tradition, addressed the transformation of the artist's experiences into a visual expression of the highest quality and should not be assigned any religious meaning. As Hofmann explained: "The life-giving zeal in a work of art is deeply embedded in its qualitative substance. The spirit is synonymous with its quality. The 'real' in art never dies, because its nature is predominately spiritual."[45]

Plasticity was created by the forces that Hofmann referred to as "push and pull," a phrase he used so often that it became nearly synonymous with his style of painting. The analogy he used to explain "push-pull" was that of a balloon being pressed on one side and consequently expanding on the other. In a painting, the visual movement of one plane forward must be counteracted by the movement of another plane back into depth in order to restore the two-dimensional balance. Each time the picture plane is stimulated, it "reacts automatically in the opposite direction to the stimulus received."[46] According to the artist's most succinct explanation, "Push answers with Pull and Pull with Push."[47] Hofmann, however, made himself most clear by demonstrating his concepts, not by talking about them. As Larry Rivers has recalled, "There was always a nude model in some pose which would make Hofmann's push and pull magic on Tuesday and Friday a more discernible reality."[48]

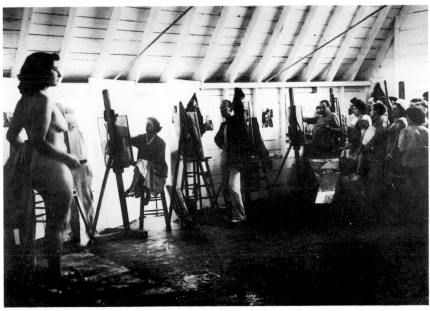

33. Hans Hofmann correcting a student's drawing, Provincetown

33

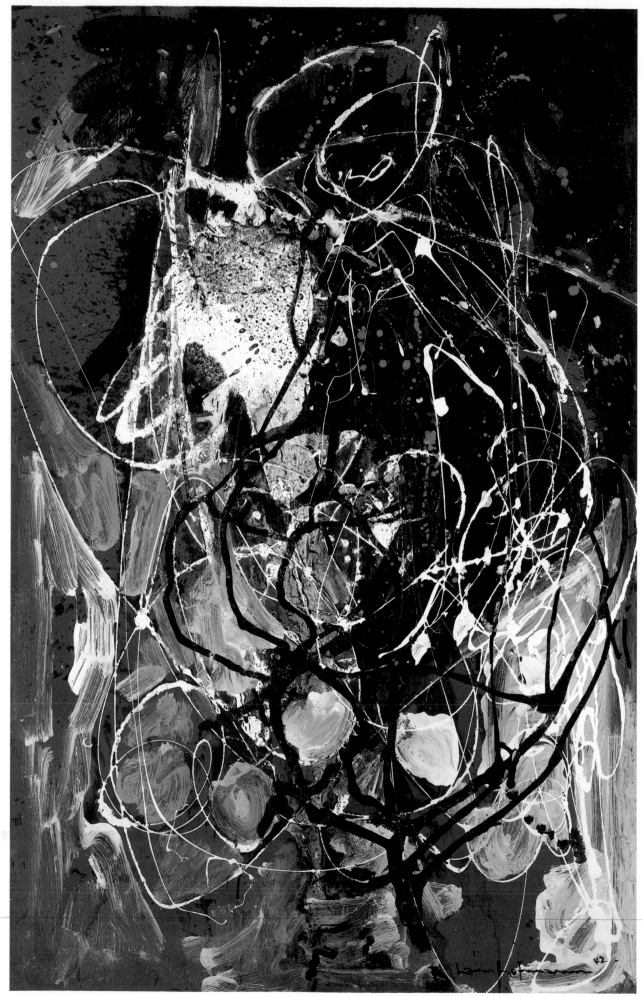

3 Breakthrough

Peggy Guggenheim's Art of This Century gallery was a primary center of activity for the many Surrealist artists exiled by World War II and for an impressive group of emerging American artists, including Pollock, Motherwell, William Baziotes, and Clyfford Still, all of whom she gave their first New York shows. Encouraged by Lee Krasner and Pollock, Guggenheim visited Hofmann's studio and offered him a one-man show in 1944. The uncharacteristic statement that Hofmann wrote for his exhibition announcement reflects the infatuation with Surrealism then sweeping the New York art world: "To me creation is a metamorphosis. The highest in art is the irrational—. . . incited by reality, imagination bursts into passion the potential inner life of a chosen medium. The final image resulting from it expresses the **all** of oneself." Nevertheless, Hofmann was ill at ease with everything but the aesthetic implications of Surrealism, and he denounced many of their tenets. He had little desire to probe his unconscious on canvas nor to grapple with literary content. However, the potential for a spontaneous gestural abstraction offered by the Surrealist method of automatism was an irresistible lure to him.

For those artists who used automatism in America during the 1940s, the technique had evolved considerably since 1924, when André Breton, the founder of Surrealism, had defined the movement itself in the first Surrealist Manifesto as "Pure psychic automatism, by which it is intended to express, verbally, in writing, or by other means, the real process of thought. Thought's dictation, in the absence of all control exercised by reason and outside all aesthetic or moral preoccupation."[49] Although automatism had fallen somewhat out of favor, in the late 1930s the Surrealist Matta, who was then in New York, began promoting the technique. Hofmann and many other New York painters espoused Motherwell's broader definition of automatism—based on the interpretations of Masson, Miró, and Picasso—as being "actually very little a question of the unconscious. It is much more a plastic weapon with which to invent new forms. And as such it is one of the twentieth century's greatest formal inventions."[50] It was just this aspect of automatism that attracted Hofmann.

34. *The Wind*, 1942(?)
Oil, duco, gouache, and India ink on poster board, 43⅞ x 27¾ in.
University Art Museum, University of California, Berkeley; Gift of the artist

Hofmann's attempts to incorporate the Surrealist technique of automatism were stimulated by the same open-minded approach to making art that enabled him to encourage experimentation and artistic independence among his students. The Surrealist Wolfgang Paalen had studied with Hofmann in Munich. According to Bultman, when Paalen and Hofmann were in contact again at about the time of Paalen's New York exhibition at the Julien Levy Gallery in 1940, Hofmann became fascinated with the canvases that Paalen produced in part by dripping tallow from a candle. In the winter of 1941–42, Peter Busa and Gerome Kamrowski, also former Hofmann students, were part of the first group of Americans, organized by Matta and including Pollock and Robert Motherwell, who experimented with automatism. Although Hofmann declined to participate, Motherwell remembers visiting him at Pollock's suggestion to ask him to join in their venture.[51]

If Hofmann's dating can be accepted as accurate, it was as early as 1939, in the painting *Red Trickle*, that his experiments with

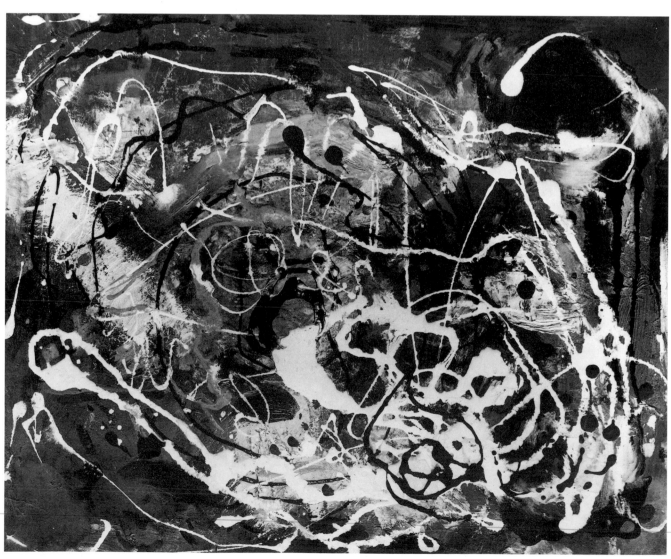

random splatters and drips of paint exhibited a spontaneity unequaled in the work of those who would soon be grouped as the New York School. Yet evidence suggests that all of Hofmann's so-called dripped paintings may have been erroneously dated. Sidney Janis vividly recalls a visit he made to Hofmann's studio in mid-1943 in the hope of including work by the artist in the *Abstract and Surrealist Art in the United States* exhibition that he was organizing for the San Francisco Museum of Art. Although Hofmann pulled out painting after painting from the bins in his studio, there was not one that could be considered abstract enough to be included in Janis's show. Approximately six months later, Miz Hofmann called Janis to announce that Hofmann had just completed a picture that could be included.[52] This was *Idolatress I*, at that time simply titled *Painting*. If Hofmann considered *Idolatress I*, which is recognizably tied to the figure, his most abstract painting to date, it is almost a certainty that *Spring* (generally dated 1940), *The Wind* (generally dated 1942), *Fantasia* (generally dated 1943), and other of his dripped paintings were painted no earlier than 1944.

In *Spring*, with its predominantly white skeins trickling and puddling in a mazelike configuration across the small picture surface, Hofmann extended his linear inventiveness, seemingly liberated from reference to any specific naturalistic imagery. *The Wind* continues to develop an uninhibited linear expression with an increasingly intricate and finely woven white and black web of paint dramatically spun out over a royal blue poster-board ground that evokes a star-filled sky. In *Fantasia*, Hofmann resumed his own investigation of the potential of linear automatism to unify a composition. Whereas linear drawing is the focus of *The Wind*, in *Fantasia* the swirling arabesques of white enamel paint function more as a decorative overlay on the fanciful multicolored ground. Hofmann's awareness of the novelty of the painting technique he used in *Fantasia* is indicated by his notation "dripped" after this title in the ledger that he kept of all his paintings.

In *Effervescence* (1944) Hofmann relied on the puddling and blotching of paint to unify his composition, rather than line. The amorphous red, white, and black forms are particularly dense in the center of this painting, as if oozing forth from some hidden source. Close inspection reveals some finely drawn notations in ink, including a clawlike foot attached to two long appendages, amidst the seeping puddles and the ocher and magenta stains. The following year, in paintings such as *Cataclysm: Homage to Howard Putzel* and *Birth of Taurus*, Hofmann again added graphic inscriptions to more loosely constructed and spontaneous compositions. In his insightful monograph on Hofmann, Greenberg focused on the artist's prophetic achievements in these two paintings. According to his criticism, *Effervescence* "predicted an aspect of Pollock's 'drip' method" as well as "Clyfford Still's anti-Cubist drawing and bunching of dark tones"; whereas *Cataclysm* "anticipated still another aspect of Pollock's later 'drip' manner." He also considered these works the first "to state that dissatisfaction with the facile 'handwritten' edges left by the brush, stick, or knife which animates the most radical paintings of the present."[53] Furthermore, Greenberg lauded Hofmann's paintings prior to 1948 for having predicted

35. *Spring*, c. 1944–45
Oil on wood panel, 11¼ x 14⅛ in.
The Museum of Modern Art, New York;
Gift of Mr. and Mrs. Peter A. Rubel

See pages 46 and 47:

36. *Fantasia*, 1943(?)
Oil, duco, and casein on plywood,
51½ x 36⅝ in.
University Art Museum, University of
California, Berkeley; Gift of the artist

37. *Effervescence*, 1944
Oil, India ink, casein, and enamel on plywood,
54⅜ x 35⅞ in.
University Art Museum, University of
California, Berkeley; Gift of the artist

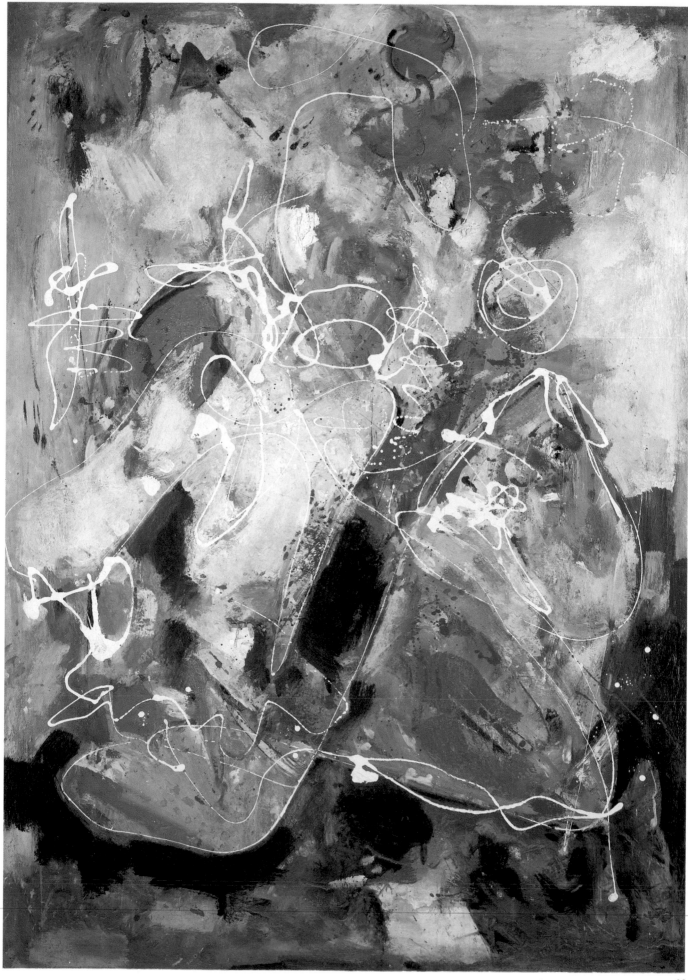

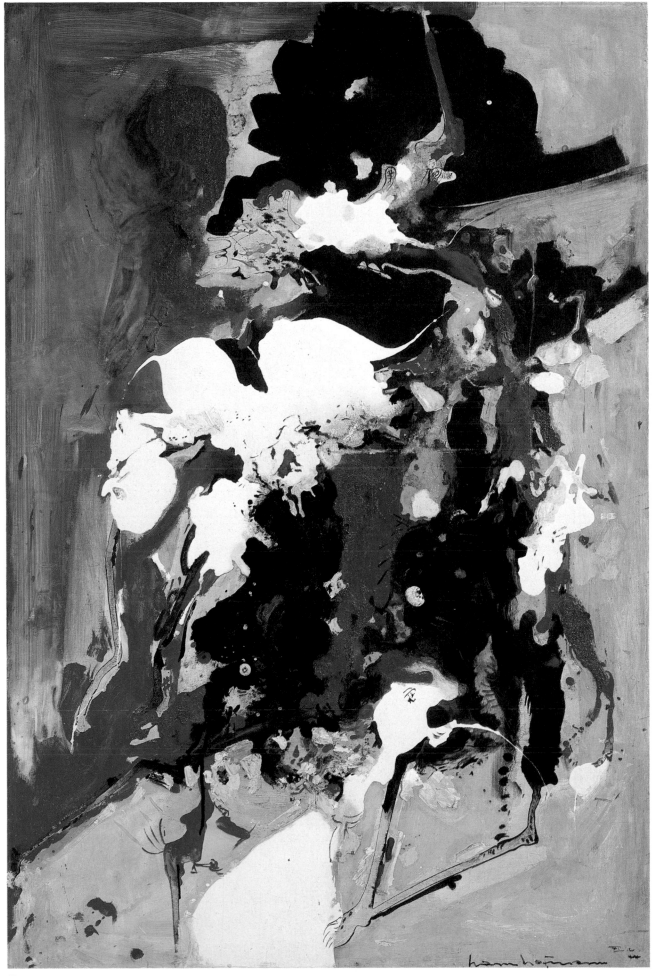

47

"the open calligraphy and 'free' shapes" that were to characterize Abstract Expressionism.

Around 1942 a number of the New York School painters became involved with mythic and primitive imagery. Hofmann had undoubtedly first encountered primitive art forms in the works of the Cubists when he lived in Paris. Fritz Bultman remembers that Hofmann returned to Germany from his first trip to the United States with an African Ivory Coast female initiation mask that he had bought in San Francisco and subsequently hung in his Munich apartment. Mythic images began to appear in Hofmann's work in 1944, the year he painted *Idolatress I*. It features a strange conglomerate creature reminiscent of both a feathered Indian princess and one of Picasso's many-profiled female portraits, such as *Seated Woman* (1927), which had recently been exhibited in several major shows at the Museum of Modern Art in New York.[54] Like *Seated Woman*, *Idolatress I* is distinguished by the flowing forms of her silhouetted lips, nose, and chin. Perhaps an even more explicit source for *Idolatress I* is to be found in Picasso's series of more than thirty whimsical renditions of the human figure called *An Anatomy*, which was reproduced in the Surrealist publication *Minotaure* in 1933. Hofmann expressed his admiration for Picasso both visually and verbally: Picasso was among the handful of artists quoted in "Creation in Form and Color" and the only one quoted more than once. Several of the articles and catalogs that were in Hofmann's library at the time of his death concerned Picasso.[55]

The droll creatures in Miró's menagerie also exerted a strong influence on Hofmann in the 1940s when the impact of the 1941 Miró exhibition at the Museum of Modern Art infiltrated the work of many New York painters. Hofmann's appreciation of Miró had begun long before. Pierre Matisse had been exhibiting Miró's work in his New York gallery since 1932, and Hofmann began advising his students to attend these exhibitions in the mid-1930s. Furthermore, among the possessions that Miz Hofmann had brought from Munich was a Miró gouache, which Hofmann later incorporated in his painting *Abstraction of Chair and Miró* (1943). In *Seated Woman* (1944), Hofmann undoubtedly paid homage to Miró's *Seated Woman II* (1944), which had been on exhibition in Peggy Guggenheim's gallery the preceding year.[56] Hofmann was rarely so explicit in his tributes to other artists, although this was not the only instance when he incorporated a painting or a section of a painting by another artist into one of his own works. Yet his references are generally so obscure as to be easily missed by the casual viewer. For example, Herbert Matter, the husband of Hofmann's student Mercedes Carles Matter, photographed a drawing of a woman by Picasso from a reproduction in a 1938 *Cahiers d'art*. Matter gave a copy of this photograph to Hofmann, who tacked it onto his studio wall and later included his interpretation of this drawing in a series of self-portraits.

Of all the American painters, Hofmann found Jackson Pollock (his neighbor on East Eighth Street in Greenwich Village) the most provocative, and a mutual respect arose between the two artists after their introduction by Lee Krasner, Pollock's wife, who studied with Hofmann from 1937 to 1940. The crux of their now-famous

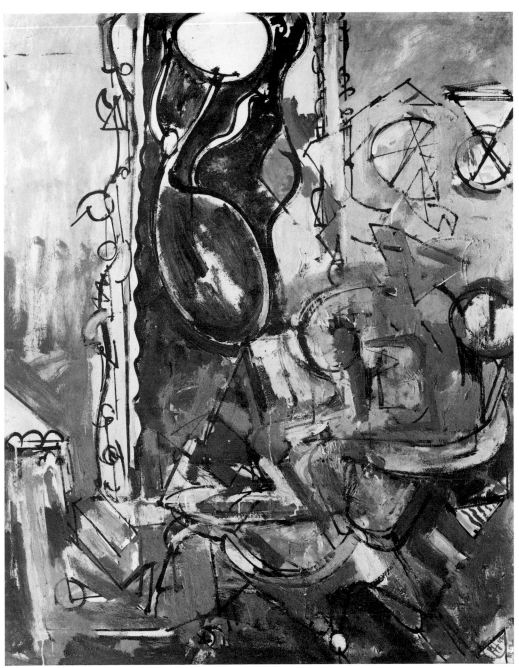

38

38. *Abstraction of Chair and Miró*, 1943
Oil on canvas, 58 x 44 in.
Collection of Muriel Francis

confrontation, when Krasner first brought Pollock to Hofmann's studio in 1942, is that Hofmann said to Pollock: "You don't work from nature. You work by heart. This is no good. You will repeat yourself." Pollock defiantly answered: "I am nature. . . . Put up or shut up. Your theories don't interest me." Despite this initial hostility, Hofmann invited Krasner and Pollock to visit his studio, and their enthusiastic response led to his show at Art of This Century. Pollock and Hofmann continued to see each other, and in the summer of 1943 Krasner and Pollock visited the Hofmanns in Provincetown. Their visits were punctuated by heated discussions on topics such as the importance of subject matter in painting. The dripped paintings that Pollock saw on visits to Hofmann's studio were undoubtedly among the catalysts for his own later explorations with dripped and poured paint—a point that Miz Hofmann was

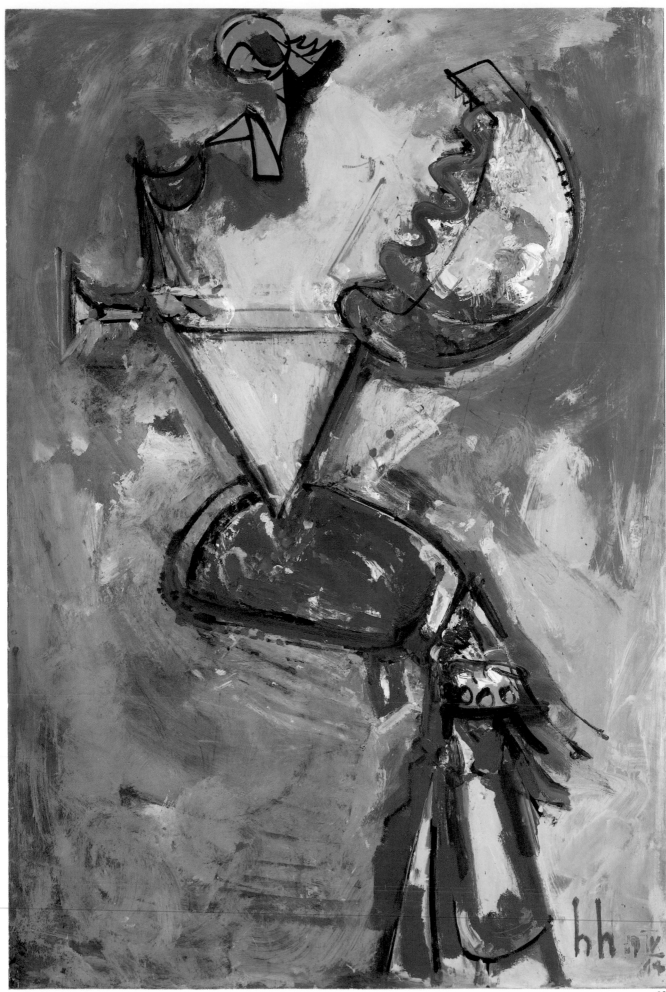

fond of making in later years and that Krasner dismissed as unimportant, saying, "Let's drop drip!"[57] As a sign of his admiration for the younger artist, Hofmann later bought two of Pollock's paintings for his own collection.

Hofmann's *Idolatress I* appears indebted not only to his own interpretation of Picasso and Miró but also to such paintings by Pollock as *Moon Woman* (1942) and *Moon Woman Cuts the Circle* (1943), both of which were exhibited in Pollock's show at Peggy Guggenheim's gallery in 1943. (Hofmann also kept a copy of the catalog from that show among his papers.) In terms of pure physiognomy, *Idolatress I* is closely related to the crescent-headed stick figure of *Moon Woman*. The imagery in *Moon Woman Cuts*

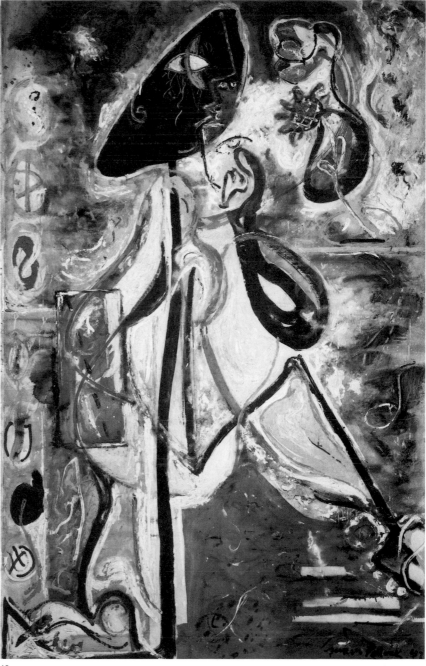

39. *Idolatress I*, 1944
Oil and aqueous media on upsom board, 60⅛ x 40⅛ in.
University Art Museum, University of California, Berkeley; Gift of the artist

40. Jackson Pollock
Moon Woman, 1942
Oil on canvas, 69 x 43¹⁄₁₆ in.
The Peggy Guggenheim Collection, Venice;
The Solomon R. Guggenheim Foundation, New York

40

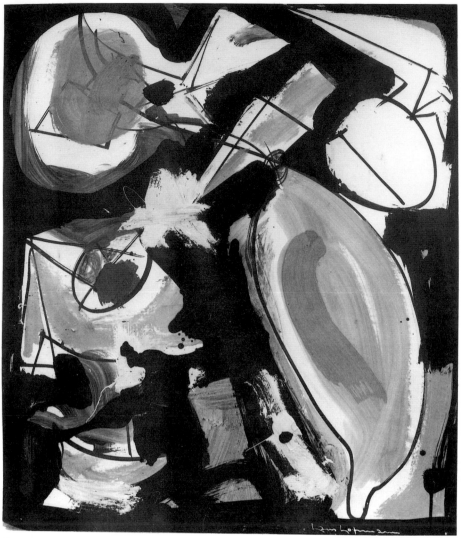

41

the Circle is more complex and more emotionally intense, but a feathered figure with multiple noses combining painterly passages and more specific linear elements is similar to *Idolatress I*.

The resemblance between some of Hofmann's paintings in his first Art of This Century exhibition and the paintings that Pollock had exhibited the year before did not go unnoticed. One critic explained the similarities with the erroneous conclusion that Pollock was Hofmann's student.[58] When asked whether Pollock had studied with him, Hofmann reputedly replied, "No, but he was the student of my student Lee Krasner."[59]

The fifteen gouaches and twelve oils in Hofmann's show at Guggenheim's gallery were unfortunately all untitled and thus now impossible to identify. According to one reviewer, who had recently talked with Hofmann, many of these pictures, which had all been painted between the spring of 1943 and the opening the following March, were "variations on the theme of the artist's Province-town house and its surrounding terrain in terms of pure color rhythms."[60] That the majority of the works in his Art of This Century exhibition were based on landscape is initially surprising

because of the Surrealistic tenor of the statement that Hofmann wrote for the announcement and because of the highly experimental work that he had supposedly been making concurrently for the previous five years. Although in terms of Hofmann's career as a whole such stylistic multiplicity is not at all surprising but rather commonplace, accepting later dates for his poured compositions is a more satisfactory explanation of why examples of these paintings seem not to have been included in this important exhibition.

There were a number of new developments in Hofmann's work during the year of his Art of This Century show that further substantiate the likelihood of his beginning to paint such works as *Spring* at this time. A hernia operation in June left him unable to carry his easel and supplies out of doors. As a consequence, he began to work inside almost exclusively, and (with rare exceptions) he no longer painted the Provincetown landscapes that had been his focus for so many years. These landscapes, as well as his interiors, portraits, and still lifes, were transformed into increas-

41. *Red Shapes*, 1946
Oil on cardboard, 25¾ x 22 in.
Sally Sirkin Lewis, Los Angeles

42. *Bacchanale*, 1946
Oil on composition board, 64 x 48 in.
André Emmerich Gallery, New York

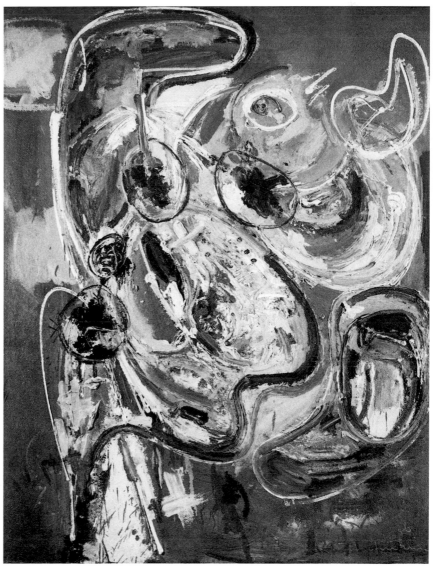

42

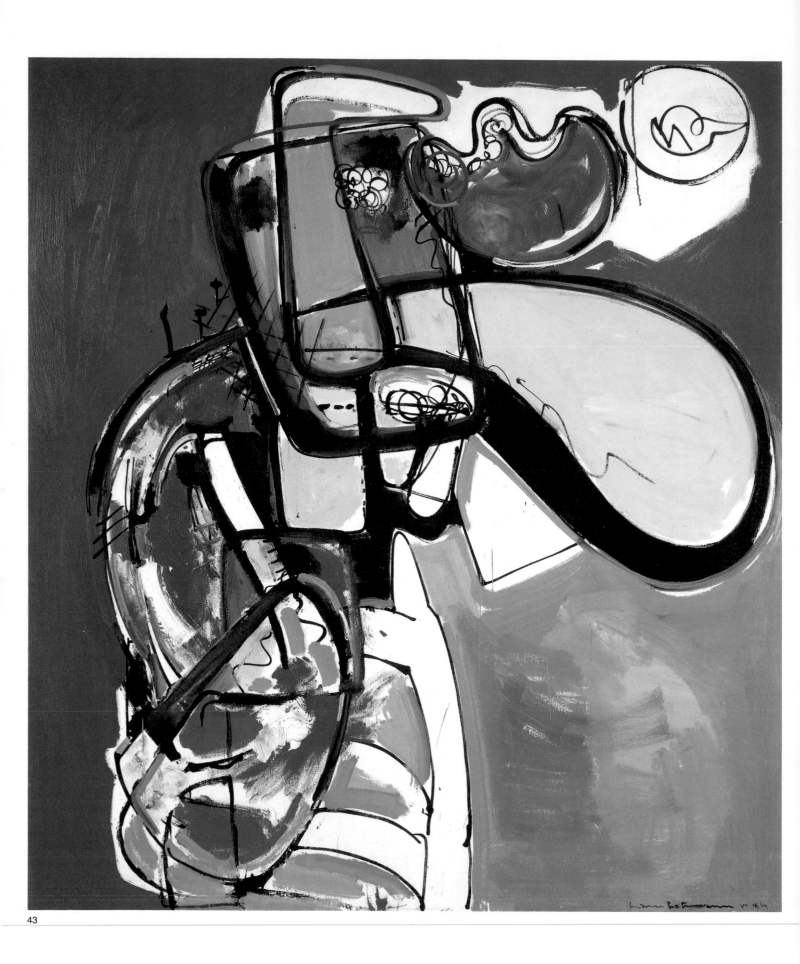

ingly unrecognizable variations on his original themes as he turned to broader, more philosophical subjects, undoubtedly in response to the other work being exhibited at Guggenheim's gallery. Hofmann's new direction was reflected in such titles as *Flow of Life*, *Life Coming into Being*, and *The Secret Source*. Among the most successful works of this transitional period were those painted in gouache or watercolor on paper. *Red Shapes*, *Midnight Glow*, *Intoxication*, and *Untitled* all date from either 1945 or 1946 and exemplify the opulently colored and highly imaginative works on paper that Hofmann called his "free creations."

Although exhibiting at Art of This Century seems to have encouraged Hofmann's responsiveness to the enthusiasms of his American colleagues, his allegiance to the European masters was still strong. In a 1945 interview he identified Kandinsky, Miró,

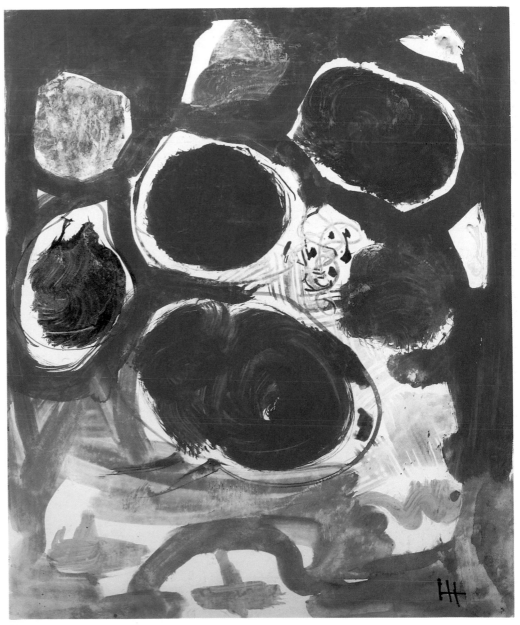

44

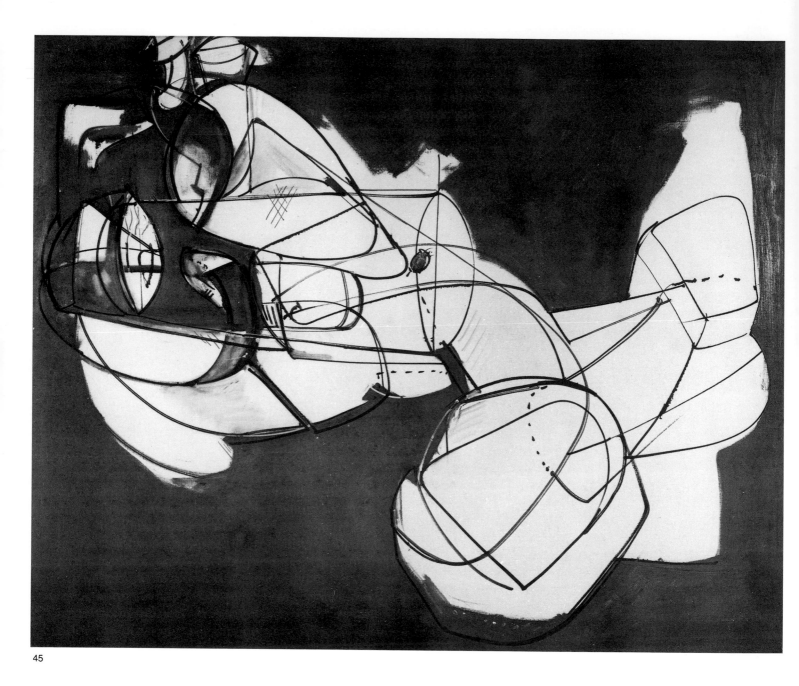

45

Hans Arp, and Piet Mondrian as the greatest innovators in modern
43 art.[61] Hofmann's enigmatic *Ecstasy* (1947) unites elements from a
number of his previous styles as well as from works by Arp and
Miró. The magenta half-moon bears some resemblance to the visage
in *Idolatress I*; the eccentric curvilinear forms seem related to the
42 curvaceous shapes in the celebratory *Bacchanale* (1946); the bil-
lowing volumes also recall the volumetric depiction of the model
in *Seated Woman*. In addition, *Ecstasy* invokes Hofmann's earlier
elaborate still-life arrangements, in which flowers and fruits meta-
morphosed into cascading patterns of colors and shapes.

In 1947 Hofmann stopped painting on canvasboard or wood
and began using canvas. The astonishing variety of styles in which
he painted during the twelve months of that year must be at least
partially attributed to his change of support. In one group of these

paintings, including *Astral Image #1* and *White in Blue*, a single 45
predominantly white figure outlined in black dominates a mono-
chromatic ground. Yet in spite of their exuberance, the painted
areas in these works still conform to linear outlines in a fairly
traditional manner. *Transfiguration* and *Delight*, also painted in 46
1947, typify a number of compositions painted primarily between
1944 and 1947 that are inhabited by benign monsters in which
human and mechanistic attributes are combined.

Hofmann's work of 1947 reflects a range of emotions as broad
as that of his styles. In an address before a 1941 meeting of the
American Abstract Artists he had explained that "Every art ex-
pression is rooted fundamentally in the personality and in the
temperament of the artist. . . . when he is of a more lyrical nature
his work will have a more lyrical and poetical quality; when he is
of a more violent nature his work will express this in a more
dramatic sense." According to this philosophy, an artist may
paint in as many styles as there are moods. If titles are an accurate
indication of "personality" and "temperament," then Hofmann's
titles, most often determined by the artist after a work was com-
pleted, reinforce his statement. Almost a random selection of titles
from 1947—which vary from the sobriety of *Dark Transition* to
the pagan celebration of *Sun Rites* to the pure jubilance of the
gaily painted *Ecstasy*—convincingly buttresses Hofmann's claim
that his paintings mirrored his wide-ranging emotions. In response
to a question about the significance of his titles in one of the last
formal interviews he granted, Hofmann again confirmed how
clearly his paintings reflected his moods: "I let things develop
according to my sensing and my feeling, to my moods, especially
those in which I find myself when I get up in the morning."[62]

Often Hofmann painted in response to a particular color, and
frequently a color is part of the title of one of his works. As he
explained: "My work is not accidental and not planned. The first
red spot on a white canvas may at once suggest to me the meaning
of 'morning redness' and from there on I dream further with my
color."[63] Generally, one should be wary of attributing too much
meaning to the title of an abstraction. Nevertheless, Hofmann's
titles are often a good indication of what he was trying to portray,
regardless of whether he started out with a pictorial concept or it
evolved while he was painting.

In a playful moment, Hofmann used his own hand as an additional
tool in *The Third Hand* (1947). Despite its title, at least four 47
hands—two green and two red—are clearly visible. To create yet
another hand form, Hofmann incised a three-pronged shape into
the green circle near the center of the painting. Other whimsical
additions to *The Third Hand* include a green eye in a fishlike
creature beneath the central green hand, a dripping blue mark in a
lighter yellow orb beneath the "fish," a large red cross above the
green orb, and a series of tic-tac-toe–like diagrams in the middle of
the left margin. Colorful circular forms like those in this picture
appeared in a number of Hofmann's compositions in the mid-1940s,
sometimes with overtly symbolic overtones, as in *Bacchanale* and
Ritual Signs, sometimes serving merely as formal devices.

Various fanciful creatures, especially fish and birds, can be seen

45. *Astral Image #1*, 1947
Oil on canvas, 48 x 60 in.
André Emmerich Gallery, New York

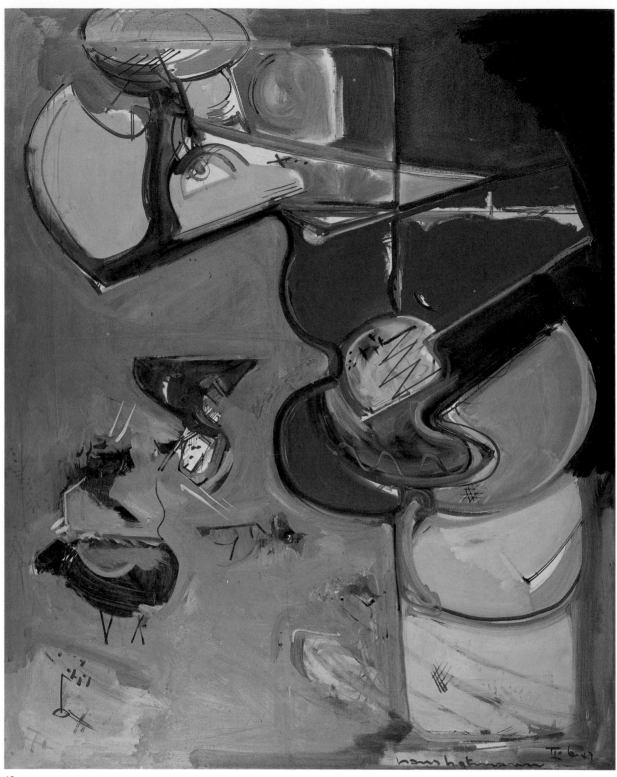

46

in Hofmann's paintings of the period such as *Amphibious Life,*
The Circus, Animals in Paradise, The Fish and the Bird, and
Bacchanale. His interest in these themes was shared by other
members of the New York School. Underwater imagery appeared
in many mid-1940s pictures by Baziotes, Rothko, and Theodoros
Stamos, while birds were a motif favored by Pollock and Adolph
Gottlieb.

46. *Transfiguration,* 1947
Oil on canvas, 60 x 48 in.
Private collection

47. *The Third Hand,* 1947
Oil on canvas, 60⅛ x 40 in.
University Art Museum, University of
California, Berkeley; Gift of the artist

47

Throughout the 1940s there was increasing awareness of revitalization and transformation of the American art scene, and numerous attempts were made to define the specific characteristics of the new style. In 1944 Robert Coates addressed this issue in an article in the *New Yorker*: "There's a style of painting gaining ground in the country which is neither Abstract nor Surrealist, though it has suggestions of both, while the way the paint is applied—usually in a pretty free-swinging, spattery fashion, with only vague hints at subject matter—is suggestive of the methods of Expressionism."[64] In the spring of 1945 Howard Putzel organized the much-acclaimed *A Problem for Critics* exhibition, which was motivated by a desire to pinpoint the distinctive features of the new art movement. Hofmann was included in this exhibition, as were Arp, Gorky, Gottlieb, Masson, Miró, Rothko, and Pollock. As Putzel explained in the press release, he grouped Hofmann with those painters who were no longer content simply to ape the European masters, but whose work manifested a "genuine talent, enthusiasm, and originality" indicative of "a real American painting beginning now." The term *Abstract Expressionism* was first applied to this new art in Robert Coates's review of Hofmann's one-man exhibition at the Mortimer Brandt Gallery in 1946. Coates wrote, "He is certainly one of the most uncompromising representatives of what some people call the spatter-and-daub school of painting and I, more politely, have christened abstract Expressionism."[65]

After his 1944 exhibition at Art of This Century, Hofmann's paintings were shown regularly in one-man exhibitions as well as in prestigious group shows. In addition to Putzel's, some of the other most important of these group shows were *The Ideographic Picture*—organized by Barnett Newman for the Betty Parsons Gallery and including work by Newman as well as by Pietro Lazzari, Boris Margo, Ad Reinhardt, Rothko, Stamos, and Still—and *The Intrasubjectives*, which Harold Rosenberg and Sam Kootz organized in another attempt to define the emerging style. In 1947 Hofmann had his first solo exhibition with Kootz, who was to be his major champion and with whom the artist showed almost yearly until his death in 1966, when Kootz decided to close his gallery. The Addison Gallery of American Art organized a solo exhibition of Hofmann's paintings and drawings the following year. As Irving Sandler has pointed out, this was the first major museum exhibition devoted to any individual Abstract Expressionist; the monograph that accompanied it similarly was the first to focus on a single painter from the group.[66]

In January 1949 a large Hofmann exhibition was organized by the Galerie Maeght in Paris. None of the other New York painters had yet received such exposure in Europe. For this occasion, an issue of *Derrière le Miroir* (published by the gallery) was dedicated to Hofmann, with "An Appreciation" by Tennessee Williams praising him as "a painter of physical laws with a spiritual intuition." Hofmann had not been to Paris since visiting Braque's and Picasso's studios on his way to America in 1930.[67] He returned to Paris at the time of his show and once again went to see Picasso, Braque, Brancusi,[68] and Miró. Even Picasso, by then an infrequent gallery visitor, came to the Maeght exhibition. The trip rekindled

48

Hofmann's sense of his position in the international art community and gave him a chance to reassess his European heritage. As he expressed it, "This visit to Paris has been a tremendous inspiration for me, I am made to feel I have roots in the world again."[69]

Hofmann strongly reiterated his affiliation with the French in an article in the California periodical *Arts and Architecture* that appeared later that year. To illustrate this piece, Hofmann drew an ovoid form in which he inscribed the following statement: "Can the egg fertilize itself . . . France has fertilized the ideas of the whole world. . . ."[70]

Hofmann maintained his pro-French stance in a one-page statement, "Protest Against Ostrich Attitudes in the Arts," which he coauthored with Fritz Bultman for the important yet still little-documented series of lectures, debates, and art exhibitions called Forum '49 that was held that summer in Provincetown. (Hofmann, Bultman, and Weldon Kees were among the organizers of these events.) Forum '49 was one of many indications in the late 1940s that New York painters were becoming more active as a group and more eager to gather together for discussion and debate. Hofmann's tenacious loyalty to the School of Paris distinguished him from most of the American vanguard, who had become increasingly outspoken about the uniquely American nature of their painting.

48. Pablo Picasso visiting Hans Hofmann's show in Paris at Galerie Maeght, 1949

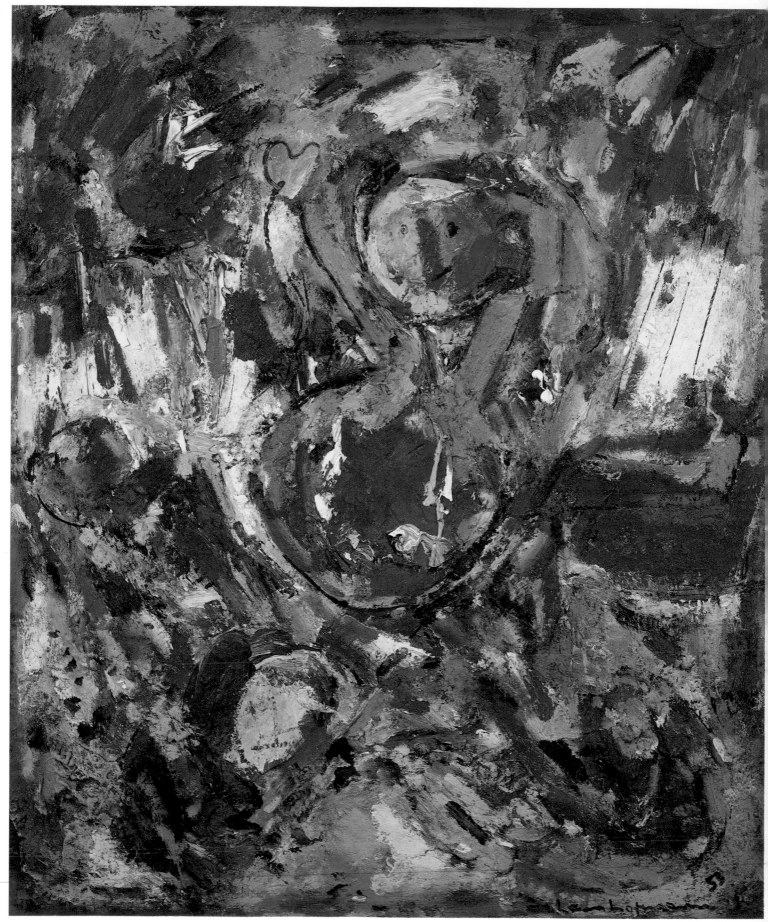

4 The Fifties

By 1950, as Clement Greenberg proclaimed, "'Abstract expressionism' jelled as a general manifestation."[71] Each of the major Abstract Expressionists was using an individual, consistently identifiable style, and their hallmark interests in wall-size scale and in compositions restricted to black and white were established. Throughout the previous decade the painters in this now-illustrious group had followed each others' shows and activities with great enthusiasm. Yet beyond the New York art community their accomplishments were little known, and they had received scant press coverage even in the art journals until the late 1940s. This situation changed abruptly in 1950, when Hofmann was one of eighteen artists—including Baziotes, Bultman, de Kooning, Gottlieb, Motherwell, Newman, Pollock, Richard Pousette-Dart, Reinhardt, Rothko, Still, and Tomlin—who wrote an open letter to Roland Redmond, president of the Metropolitan Museum of Art in New York, to protest what was viewed as the provincialism of the jury for an exhibition of contemporary American art scheduled for that winter at the Metropolitan. Dubbed the "Irascibles" by the press, the group won widespread media coverage, and a photograph of them (which did not include Hofmann) was published later that year in *Life* magazine. Although Hofmann did not share all the interests of the Abstract Expressionists (he never painted on a truly monumental scale, he limited his palette to black and white in only a few instances, and he refused to use a uniformly recognizable style), he emerged as a central figure in the new American vanguard.

In April 1950 he was one of a select group to participate in a three-day symposium at Studio 35 in New York. (Much of the proceedings of this conference was published in 1952 as *Modern Artists in America*, edited by Motherwell and Bernard Karpel.) The following year Hofmann was among the sixty-one painters and sculptors represented in the *Ninth Street Show*, which was organized by members of the Eighth Street Club, a focal point of Abstract Expressionist activity during the decade after its founding in 1949. Once again, this event surprised its participants by the amount of attention it attracted.

Certain of his pictures from the 1940s and '50s, such as *Pink Phantasie* (1950), linked Hofmann with such Abstract Expression-

49. *Le Gilotin*, 1953
Oil on canvas, 58 x 48 in.
University Art Museum, University of
California, Berkeley; Gift of the artist

ists as Pollock, de Kooning, James Brooks, Franz Kline, and Philip Guston, who were grouped as "gesture painters" to distinguish them from the "color-field" painters led by Clyfford Still, Rothko, and Newman. Whereas the latter group minimized touch, emphasized color, and treated the canvas as a unified field, the "gesture painters" were primarily concerned with creating overall images composed of fluid, expressive gestures. The dynamic, frequently unfinished quality of their canvases seemed to imply a life beyond the edge of the composition, and these painters often described the metamorphosis of their images as paralleling their own perpetually evolving personalities and fluctuating moods. Although usually associated with the "gesture painters," Hofmann clearly had affinities with both groups.

In 1950 the Museum of Modern Art organized a large exhibition of work by the Lithuanian-born artist Chaim Soutine, which Hofmann viewed with great enthusiasm. At times virtually dissolving his subject matter in massive waves of pigment, Soutine expressed a veneration for the plastic potential of paint that Hofmann fervently shared. Astutely noting the importance to Hofmann of both Soutine and Paul Klee, Greenberg suggested that they may have been the first painters to address "the picture surface consciously as a responsive rather than inert object and painting itself

50

as an affair of prodding, pushing, scoring, and marking rather than simply inscribing or covering the flatness of such an object." Yet Greenberg concluded by asserting that Hofmann's own animation of the surface surpassed that of both these artists, and he partially credited him for the fact that the "'new' American painting in general is distinguished by a new liveliness of surface, which is responsible in turn for the new kind of 'light' that Europeans say they find in it."[72]

By varying textures with impastoed peaks, thick squiggles, short dabs, and ploughed ridges, Hofmann masterfully created vivacious surfaces in numerous paintings of the early 1950s, including *Bouquet*, *Blossoms*, *Flowering Waves*, and *Le Gilotin* ("The Guillotine"). He employed dense pigment not only for its tactility but also for its chromatic effect. As the artist explained: "Texture is the consequence of the general pigmentary development of the work, and becomes in this way an additional light-producing factor, capable of altering the luminosity of the colors in the pace of their development towards a color totality."[73] Most of Hofmann's paintings with heavily encrusted surfaces are without figurative elements. The sketchily drawn figure in *Le Gilotin*, presumably the unfortunate personage condemned to execution, emerges from the sweeping applications of paint as if an afterthought.

By creating mosaiclike clusters of paint through a staccato application of polychrome pigment, Hofmann developed another highly effective technique for creating tactility and movement, which he used extensively in the early 1950s. In *Scintillating Space* (1954) these pulsating flecks contrast sharply with the architectonic substructure of red and blue planes set on a predominantly green background. Hofmann's use of such small areas of frequently dense paint might seem to signal an altogether new surface treatment, but, in fact, it attests to the continued importance of Neo-Impressionism for the artist. Furthermore, the red and blue planes lurking behind the bright specks of paint resemble the forceful mechanical-looking forms that appear in many of his pictures of the late 1940s. Unfamiliar as they may seem at first, these angular shapes originated in Hofmann's numerous still lifes, figure studies, and diagrammatic classroom drawings in which he transformed the volumes of nature into planes.

In paintings such as *Scintillating Space*, the pointillist dabs of color serve merely as a highlighting device, but they quickly proliferated until in *The Garden* (1956) they cover virtually the entire surface. The garden of the Hofmanns' white frame house on Commercial Street in Provincetown, carefully tended by Mrs. Hofmann, blazed with color during the summer months, and flowers were a frequent subject of her husband's paintings. *The Garden*, with its sumptuous array of multicolored blooms, epitomizes Hofmann's exuberant depictions of Miz's cherished flower beds.

In *Fragrance*, also of 1956, Hofmann pushed the use of heavily applied pigment to its farthest limits: the entire surface of this seductively tactile painting is covered by chromatic dabs of paint that seem mysteriously animated, as in contemporaneous works by Philip Guston. Hofmann believed that his paintings were to be experienced not only by sight but through all the viewer's senses:

49

51

52

53

50. *Volumes in Balance*, 1950
Oil on canvas, 42 x 60 in.
Private collection

66

51

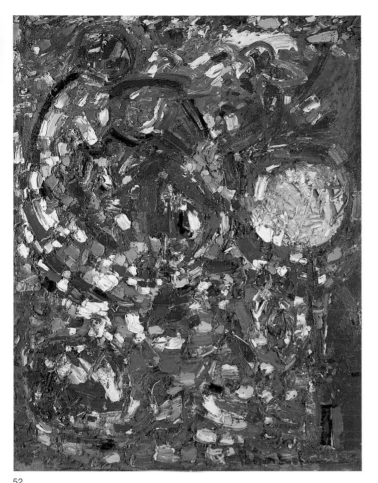

52

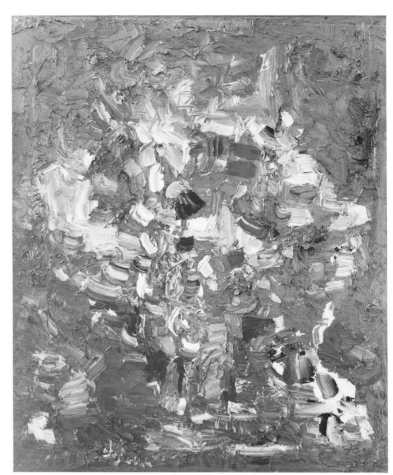

53

51. *Scintillating Space*, 1954
Oil on canvas, 84⅛ x 48⅜ in.
University Art Museum, University of
California, Berkeley; Gift of the artist

52. *The Garden*, 1956
Oil on plywood, 60 x 46⅜ in.
University Art Museum, University of
California, Berkeley; Gift of the artist

53. *Fragrance*, 1956
Oil on canvas, 60 x 48 in.
Honolulu Academy of Arts; Purchase, 1968

"We hear, smell, and touch space."[74] The opulent application of gemlike colors in *Fragrance* was meant to stimulate the viewer visually and also to conjure the smell of a densely planted flower bed in full bloom. Aware that more than just visual factors contribute to the processes of making and perceiving works of art, Hofmann also took emotional and intuitive elements into account. As he explained, empathy was the primary quality needed not only to produce art but also "to experience art, to enjoy art, and particularly to criticize art."[75] Rooted in the German philosophical tradition, Hofmann defined empathy as "the intuitive faculty to sense qualities of formal and spatial relations, or tensions, and to discover the plastic and psychological qualities of form and color."[76] The artist who possesses empathy is able to penetrate the exterior appearance of objects in the visual world and convey their essence to the viewer by creating a new reality in the form of a work of art.

At the same time that Hofmann was producing richly textured paintings, he was also making more structured and spare compositions. One group—typified by *Blue Balance* (1949), *Volumes in Balance* (1950), and *Red Lift* (1951)—is dominated by large planes of color, many of them roughly triangular, with origins in the bright, flat planes of Synthetic Cubism. In another group of paintings—which includes *Carnival* (1949), *Jubilant* (1953), and *Untitled* (1954)—Hofmann propelled Miróesque multicolored dots, crosses, circles, and squiggles across bright white grounds. Rather

50

54

than referring to any specific images, the gaily colored shapes in these paintings evoke a carefree state of mind.

Interior scenes and still lifes continued to appear with varying degrees of recognizability into the mid-1950s, with Hofmann never hesitating to revert from the seemingly abstract to the naturalistic. Whereas the subject of *Interior* (1947) is identifiable only because of the title, the color-drenched *Magenta and Blue*, painted two years later, is visually explicit about its subject matter. Among the objects on the left side of the table are a pitcher, two large pieces of yellow fruit, and a decoratively striped orange pineapple. The striations are echoed on the wall behind it in what looks like either a piece of cloth or the lattice pattern of a window. The subject and the large areas of highly saturated color suggest that this painting is a tribute to Matisse, who had exploited the decorative potential of a pineapple in a number of similar settings, including *Still Life in the Studio* (1924). *Magenta and Blue* represents a considerable refinement of Hofmann's vocabulary, exemplifying, as critic Harold Rosenberg said, "the degree to which Hofmann's later interiors have been swept clean by cerebral gusts."[77]

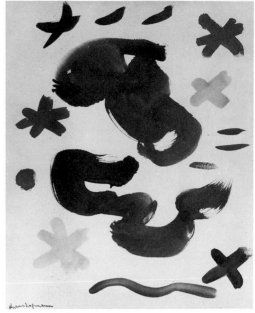
54

By 1952 Hofmann was represented in the collections of many of the preeminent American art museums, including the Art Institute of Chicago, Metropolitan Museum of Art, Museum of Modern Art, Walker Art Center, and Whitney Museum of American Art. His exhibitions in both New York and Provincetown were well-attended events: over seven hundred people came to the opening of his 1953 summer show at the Kootz Gallery in Provincetown. Yet he could still not rely on the sale of paintings as his sole income. As Sam Kootz lamented, "Collectors only started to catch up with him in 1955, and even that season accounted for only $14,000 in sales."[78] Largely for this reason, he continued his strenuous year-round teaching schedule longer than he otherwise would have done; his recognition that the demands of the school drained his own creative energy bothered him for some time before he actually stopped teaching. In a letter from Provincetown in the summer of 1953, he wrote, "My own creative work suffered slightly partly through the weight of the school. . . . I will soon be seventy-four years old and should from now give all my own energy to my own work. As European of birth I have not yet acquired the American elasticity of constant change and that makes my decisions more difficult."[79]

Probably not only financial considerations and what Hofmann referred to as his "inelasticity," but also the enormous sense of responsibility that he felt toward his students and the desire to ensure somehow the continuity of the school and his teaching tradition compounded the difficulty of his decision. A troubled Hofmann talked to Motherwell about the possibility of his taking over the school. Yet in spite of his misgivings and his fear of encroaching frailty, Hofmann exuded a tremendous physical vitality that belied his years. Motherwell, who saw Hofmann both in Provincetown and at the dinners that Sam Kootz regularly arranged for his gallery artists in New York, recently recalled with amazement that there was never any "sense of decay" about Hofmann in spite of his age. He maintained a strong physical presence, robust

handsomeness, and a radiant smile, and even when the artist was quite old, one "could still relate to him in a vital way."[80] Sometimes Hofmann's dark thoughts and trepidations manifested themselves in his pictorial universe, where all was not as idyllic as his many joyous compositions might lead the viewer to believe. In *The Prey* (1956), a picture about which Hofmann claimed, "for this you need to be in the rarest states,"[81] the artist flung onto the painting surface a disturbing image that seemingly resulted from a foray into his unconscious. This rather startling silhouetted specter hovers in predatory fashion above a targetlike configuration in the bottom left corner, which looks as if Hofmann created it by dripping black paint on the canvas one dot at a time. This spiral form is echoed—although far less distinctly—in blue at the lower right and in red at top left. Rather playful marks in yellow, green, and blue ameliorate the sense of impending doom.

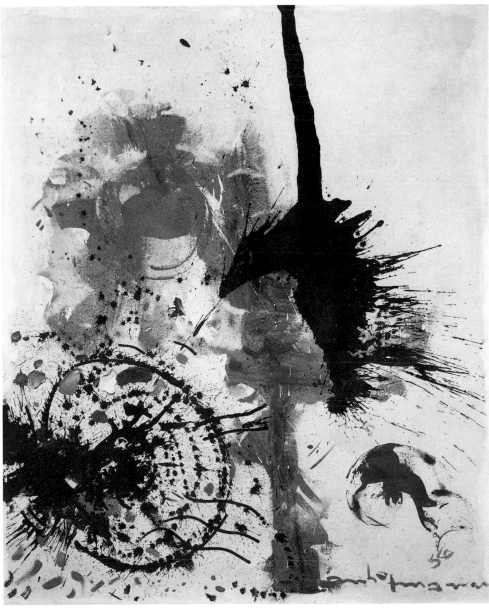

55

Beginning in 1955 the artist sought to instill an immediately comprehensible internal logic in his canvases. The rectangle, which would later be recognized as the hallmark of his style, was about to emerge in its mature, full-bodied form. In the seminal painting *Radiant Space*, the still only roughly rectangular areas are coated with a washy application of paint. The intensity of the bright composition is softened by the generous areas of white canvas around the rectangles. The result is a luminosity and solidity that Hofmann would frequently attain in his late work. The orange, red, and black lines doodled across and between the rectangles is a calligraphic device often deftly employed in the midst of Hofmann's densest compositions. He used such lines sparingly, dismissing their ability to control pictorial space. According to his explanation, "A line may flow freely in and out of space, but can not independently create the phenomenon of 'push and pull' necessary to plastic creation."[82] Nevertheless, Hofmann frequently seemed compelled to elaborate his compositions with graphic elements. Not until the paintings of his final decade was line consistently successfully subordinated to color and form.

Solidified rectangles first figure as a major compositional element in 1956, the year Hofmann made both *Blue on Gray* and *Yellow Burst*, and from this time on, he was irrevocably committed to their use. *Circles*, also painted in 1956, offers rare insight into Hofmann's way of working. In this composition he stapled a number of rectangular pieces of green and orange paper onto a brilliant whirlwind of squiggles and spheres. The fact that these shapes were applied in this tentative manner rather than painted directly onto the surface implies Hofmann's initial hesitation about incorporating them. Even when rectangles had become entrenched in his artistic vocabulary, he still tested their locations by tacking planes of various sizes and colors onto a surface before painting them. Close examination of many of his pictures with rectangular

57

56. *Circles*, 1956
Oil on cardboard, 12 x 31 in.
Private collection

57. *Radiant Space*, 1955
Oil on canvas, 60 x 48 in.
Carter Burden, New York

58. *Pompeii*, 1959
Oil on canvas, 84¼ x 52 in.
The Tate Gallery, London

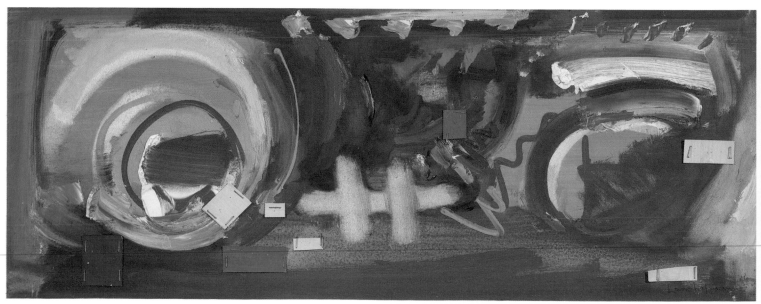

56

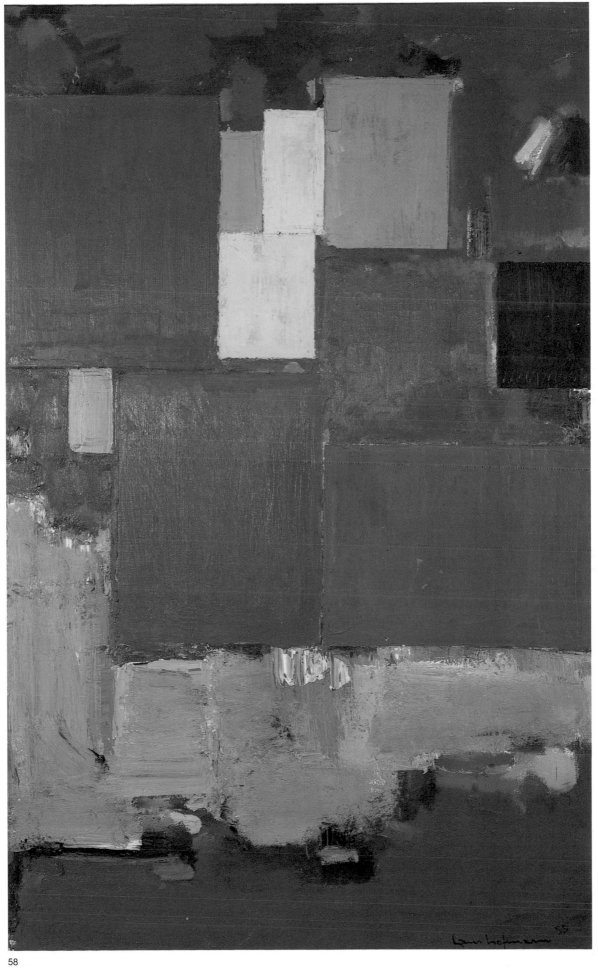

components reveals tack marks where his application of pigment was not thick enough to cover them.

Hofmann originally tested the location of planes with hand-colored paper, but in later years he cut the forms out of the commercial Color-Aid paper available in art supply stores. After his death, there were found among the artist's possessions several portfolios filled with stacks of these papers cut into rectangles that can be related to specific late paintings by their size and color. This method of construction was surely a carryover from the exercises that Hofmann had given to his advanced still-life classes in Munich. He instructed them to adjust the color tensions of their final compositions by pinning little pieces of colored paper onto their canvases before painting them. Hofmann's painstaking positioning of each plane reflected his belief that moving any element of the composition "even a millimeter" had enormous implications for the entire composition. Changing the location of a plane gave it an "absolutely different meaning."[83]

Hofmann's use of the plane as a major compositional element had numerous art historical precedents in the work of the Cubists as well as Klee, Arp, and Mondrian. Although Hofmann's philosophy was already well formulated by the time he read Mondrian's essays and the presence of the rectangle had been pervasive in his classroom lectures and theoretical writings ever since he had begun teaching, Mondrian's painting and writing gained in importance to Hofmann as his own work became increasingly dominated by rectangular planes. Like Hofmann, Mondrian had been in Paris from 1912 to 1914 and based much of his theory on the prevailing Cubist aesthetics. Hofmann may have encountered Mondrian's ideas while he was still in Europe; however, it was once he was in the United States that Hofmann immersed himself in the artist's theory. In his personal copy of the book *Circle*, Hofmann made copious notes in German and English in the margin of Mondrian's essay "Plastic and Pure Plastic Art" and underlined numerous passages one or two times.[84] Hofmann also read and reread the essay "Toward the True Vision of Reality," published in the catalog for Mondrian's 1942 exhibition at the Valentine Dudensing Gallery in New York, in which he addresses the rectangle as a compositional device.[85] A passage containing the observation that when rectangles appear alone they are not particularly remarkable "because it is in contrast with other forms that occasions particular distinction" was underscored three times in the margin of Hofmann's catalog. This premise of interdependence was central to Hofmann's compositions, and he frequently elaborated on it, explaining that "It is the relation between things that gives meaning to them. . . . The relative meaning of two physical facts . . . always creates the phenomenon of a third fact of a higher order."[86]

Most of Hofmann's instructional diagrams concern the different effects created by planes according to the way they relate to each other on the picture surface. He made a primary distinction between compositions that rely on overlapping planes and those that achieve "pure pictorialization without overlapping" through a phenomenon he called "shifting." In overlapping, the compositional vitality depends greatly on the order of the overlapping planes—that is,

59

which plane is on top, which is on the bottom, and which is in the middle. Altering the order of the overlapping planes completely changes the composition. Yet there were certain limitations to the spatial effects that could be achieved through overlapping: "Overlapping always produces a realistic or naturalistic effect—it is still not yet pure pictorial realization. . . . In pure plastic creation planes are not allowed to overlap but do shift 'under them' in relation to the picture surface and this in accordance with the realization of a plastic idea."[87] Shifting—the more sophisticated compositional device—creates the illusion that non-overlapping planes move forward or backward by locating them higher or lower, to left or to right in relation to each other on the picture plane, rather than relying on the stepladderlike effect of overlapping planes. Such shifting became increasingly important to Hofmann in his later compositions.

Frequently Hofmann demonstrated his compositional principles by drawing Cubistic diagrams in the margins of his students' compositions, a practice begun when he started teaching in Munich in 1915. At first he corrected their drawings rather literally, but later he started "to draw only diagrammatically because so many students copied his style without understanding it."[88] Unlike his discussions of art, which sometimes seemed unnecessarily abstruse, Hofmann's instructional diagrams and drawings were simple and direct, and for many students they were most effective in clarifying his ideas. Students usually, but not always, welcomed Hofmann's alterations. Krasner recalled with disgust an incident from her student days when Lillian Kiesler was monitor for the night class. Kiesler was very enthusiastic about the drawing Krasner was working on, and both women eagerly awaited Hofmann's arrival so they could show it to him. Instead of the expected approval, Hofmann's reaction was to tear the sheet into four pieces, one of his standard ways of demonstrating how to vitalize a composition.[89] Shifting the ripped paper to the right and to the left, he would proclaim, "This is tension." Hofmann's responses were always unpredictable, and the classroom was emotionally charged in anticipation of his forceful reactions to the students' work.

Since Hofmann placed greater value on the act of painting than on final appearance, students searching for a master plan were often confused. James Gahagan, one of the monitors in the last years of the school, recalls a frustrated student's demand that Hofmann tell him the secret of his corrections. Hofmann matter-of-factly replied, "Ah yes, there is a secret, but you must find it yourself. It does not belong to me."[90]

After teaching for more than forty years, Hofmann finally closed both his schools in 1958. Even though he was no longer regulated by an academic schedule, he continued to divide the year between Provincetown and New York, where he maintained his former school space at 52 West Eighth Street as his studio. As devoted as Hofmann had been to his students, the time-consuming and energy-draining responsibilities of running a school had undoubtedly circumscribed his productivity as an artist. The paintings he created during the last eight years of his life exhibit an almost unequaled exuberance and breadth of creativity.

59. *Untitled* (lecture demonstration drawing), 1942
Charcoal on paper, 25 x 18⅞ in.
The Metropolitan Museum of Art, New York

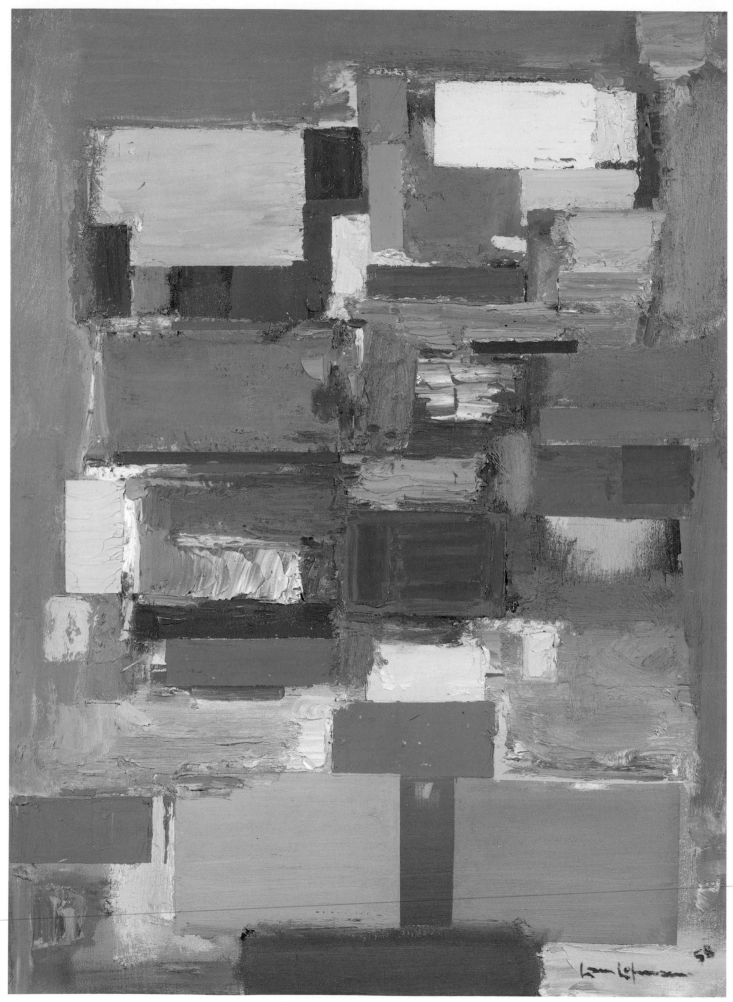

The Late Paintings

Even though Hofmann was still experimenting with his mature style, it was clear by 1958 that the rectangle had become the primary spatial organizer of his compositions. In *Morning Mist* the presence of the rectangle is so forcefully felt that even areas that are only roughly rectangular seem more geometric than they actually are. *Morning Mist* is one of the most diversified of Hofmann's paintings in terms of the varied proportions and surfaces of the rectangles: some are dense with agitated brushstrokes and peaks of paint, others are much smoother. Horizontal slivers of blue, umber, red, magenta, and pink have been inserted between the larger rectangles of light purple, yellow, and various greens. 60

In *Morning Mist*, *Kaleidos* (1958), *Towering Spaciousness* (1956), and other vertical paintings, the planes that cascade from the top are anchored at the bottom and sparsely distributed at the sides, recalling the organization of Analytic Cubist figure paintings such as Picasso's *Ma Jolie* (1911–12). This figurative analogy is substantiated by Hofmann's comment that all subject matter could be reduced to a succession of planes; the model or still life was simply a point of departure for an exploration of space "disclose[d] through volumes." Students such as Myron Stout and Jan Müller took his teachings to their furthest extreme by dissolving the subjects of their figure studies beyond recognition into arrangements of variously shaded planes. 61

In *Equipoise* (1958) the assertive strength of the rectangle is fully manifest, in spite of the disruptive potential of the small rectangular elements nestled in a cruciform shape in its center. *Equipoise* is basically organized around four large rectangles, each of which occupies about one-sixth of the canvas and is anchored in or near one of the corners. In some of Hofmann's rectangle pictures such as *Equinox* (1958) and *Morning Mist*, almost the entire surface is covered with a complex organization of rectangles, none of which is decisively dominant in color or scale. *Equipoise* is more closely related to paintings such as *Smaragd Red and Germinating Yellow* (1959), *Song of a Nightingale* (1964), and *Te Deum* (1964), in which Hofmann superimposed a more limited number of larger rectangles over opulent beds of paint. Hofmann considered form and color to be synonymous, and he was fond of 63 64 65 62

60. *Morning Mist*, 1958
Oil on canvas, 55⅛ x 40⅜ in.
University Art Museum, University of
California, Berkeley; Gift of the artist

61

62

61. *Kaleidos*, 1958
Oil on plywood, 72⅛ x 31⅞ in.
Whitney Museum of American Art, New York;
Promised gift of Mr. and Mrs. Leonard S. Field

62. *Te Deum*, 1964
Oil on canvas, 50 x 60 in.
Paul and Helen Zuckerman, Franklin, Michigan

See pages 78 and 79:

63. *Equipoise*, 1958
Oil on canvas, 60 x 52 in.
Weisman Family Collection/Marcia S. Weisman

64. *Equinox*, 1958
Oil on canvas, 72⅛ x 60¼ in.
University Art Museum, University of
California, Berkeley; Gift of the artist

repeating Cézanne's maxim that "when color is fullest, form is richest."[91] Fulfilling this dictum, these paintings are some of the most powerful and exuberant expressions in all of modern art.

In spite of his growing critical and financial success (by the 1962–63 season, his yearly sales were above $200,000), Hofmann was still meeting plenty of resistance from the art establishment. His omission from the important *New American Painting* exhibition that the Museum of Modern Art sent to Europe in 1959 is a prime example. The lukewarm feelings of Alfred Barr, director of the Museum of Modern Art, toward Hofmann and his work were notorious. The very fertility of his creative vision still conspired against him. His increasing success changed Hofmann's lifestyle only slightly. For public occasions, he would now reluctantly shed his preferred painter's garb and don a traditional gray suit. And, after years of listening to the admonitions of their concerned friends, in about 1960 Hans and Miz finally gave up their fifth-floor walkup and moved into a larger apartment—replete with all the modern amenities their previous apartment had lacked—in the Washington Square Village apartment complex in Greenwich Village.

Hofmann's years of observing nature left a lifelong imprint on his art. In later years, when he no longer painted directly from nature, he insisted that it was not necessary because "I bring the landscape home in me."[92] Therefore, despite his seeming turn to nonobjectivity, the explicit natural references of paintings such as *Daybreak* and *Rising Sun* (both 1958) come as no surprise. Even

64

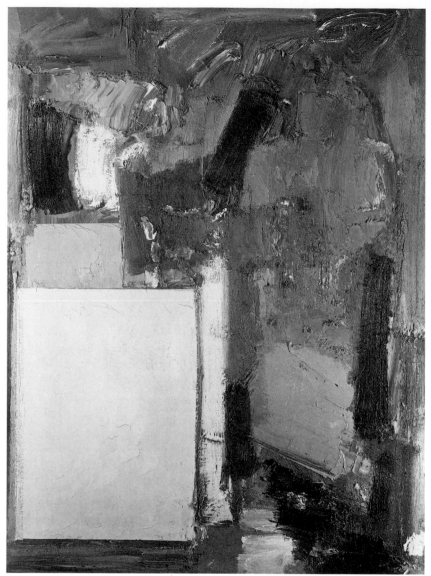

65

66 in the sublime late painting *Ora Pro Nobis* (1964), a haloed solar form in a glowing yellow field emerges from the dark slabs below it like the sun from the last obscuring clouds of night. Those who knew Hofmann in Provincetown recall that one of his greatest pleasures was driving out to the beach with Miz late every afternoon to watch the sunset. His description of *Scattered Sunset* (1961), a blazing portrayal of the sun's final rays, is as true for this theme as for all his later interpretations of nature: "When I paint a sunset I paint actually thousands of sunsets of which I was part when I did enjoy them through all my Life. I am—and whatever I do is—part of nature with the added and unconciliatory difference that I allow myself never to renounce the aesthetical demands of creation."[93] How to capture nature with paint while remaining respectful of the inherent differences between pictorial experiences and those of the natural world endured as one of Hofmann's main preoccupations. In his major statement on color, "The Color Problem in Pure Painting—Its Creative Origin," published in the cata-

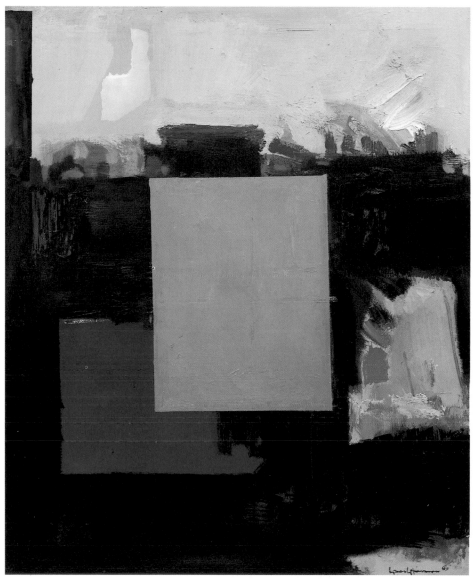

66

log for his 1955 exhibition at the Kootz Gallery, Hofmann asserted, "In nature, light creates the color: in the picture, color creates light." Even when sunlight was no longer the direct source of illumination for his paintings, it pervaded Hofmann's palette.

Seascapes and other aquatic themes always fascinated Hofmann. During his summers in Provincetown the Atlantic Ocean and Provincetown Bay were constant presences, and he frequently incorporated these bodies of water into his landscapes. In the late 1950s he turned his attention to aquatic subjects with renewed fervor. *The Ocean*, *The Pond*, *Oceanic*, *Above Deep Waters*, and *Aquatic* 67 *Gardens* each captures the sensation of or an emotional response to a different aquatic environment.

Hofmann, who continued teaching through two world wars, believed that political events should not affect either his instruction or his work. On a few occasions, however, a world-shattering event became the point of departure for one of his paintings. *Cataclysm: Homage to Howard Putzel* (1945) was painted in

65. *Smaragd Red and Germinating Yellow*, 1959
Oil on canvas, 55 x 40 in.
Cleveland Museum of Art

66. *Ora Pro Nobis*, 1964
Oil on canvas, 60 x 48 in.
Private collection, New York

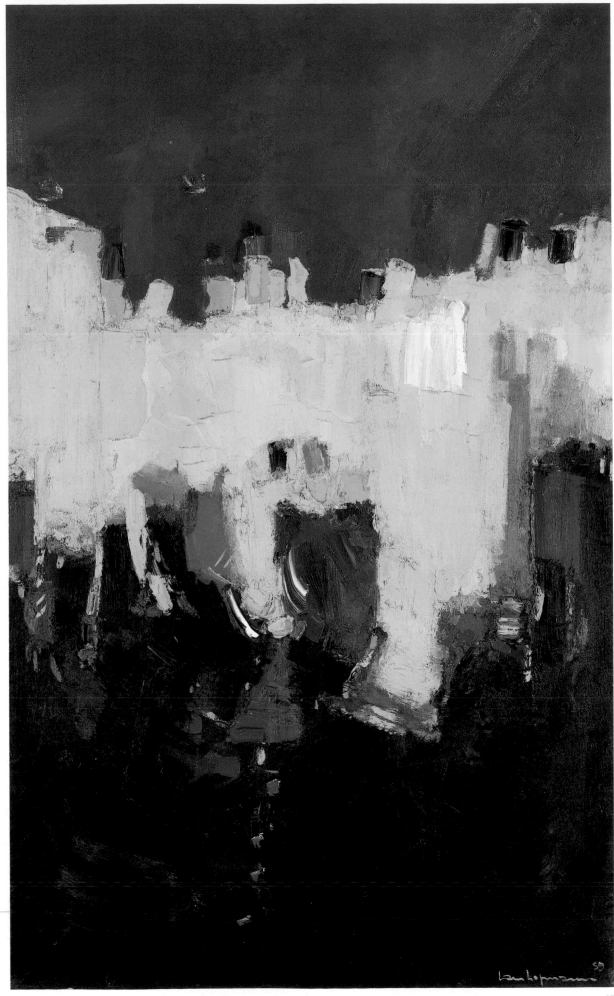

67. *Above Deep Waters*, 1959
Oil on canvas, 84¼ x 52 in.
University Art Museum, University of
California, Berkeley; Gift of the artist

68. *Festive Pink*, 1959
Oil on canvas, 60 x 72 in.
Mr. and Mrs. Kenneth N. Dayton

response to Hiroshima, *Nucleus Blast* (1962) in reaction to nuclear testing, and *To JFK—Thousands Die with You* (1963) was painted in anguish over the assassination of President Kennedy. Yet these examples are unusual, for Hofmann was much more likely to react to the season or to a particular landscape than to current events. For the most part his work reflected his responses to his own feelings and to the people and the world immediately around him.

A letter that Hofmann wrote to Erle Loran offering to give the University of California one of three paintings as testimony to his gratitude to Worth Ryder reveals how the artist chose to convey his emotions through both color and composition. The following passage from this correspondence is a rare verbalization of his pictorial intentions:

> . . . the large flat colour plane[s] serve . . . as pillars to create the immensity of California's colourful saturated space. In the same time they symbolize through the colour that brought them into existence a feeling of luminous fertility and voluminous saturation. . . . intended to suggest physical and spirited health as I have experienced it through my staying in California. . . .[94]

There is little doubt that the picture Hofmann was describing is *Land of Bliss and Wonder, California* (1960). This monumental composition typifies the emotional response that was triggered in Hofmann by the American terrain. From the swamps of Cape Cod to the mountains of California, the American topography proved as liberating to Hofmann as the artistic milieu.

Another passage in Hofmann's letter explains how the subjects of his paintings influenced the way he applied his strokes to the

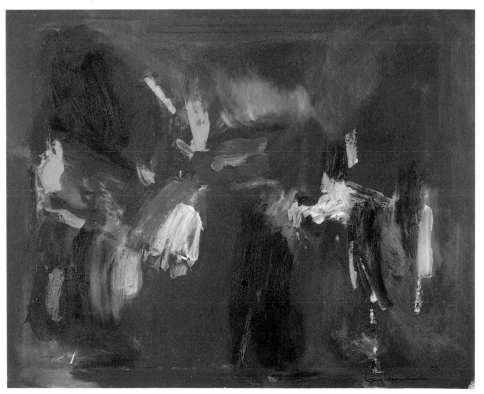

68

83

picture surface as well as the colors he used. In *Cascade*, for example, he tried to "express the idea of its title" through "contrasting vertical and horizontal and diagonal oppositions and motions and color dictated rhythms." Similarly, the wildly varied

69 stroking and jabbing gestures of *In the Wake of the Hurricane* (1960) capture some of the sense of pandemonium caused by a natural disaster. The rapidity with which Hofmann applied the short strokes aptly conveys the relentless rush of rain being swept along by hurricane winds; a fairly generous use of thick white paint suggests frothing waves. Despite the frantic activity, the composition is given solidity by its organization around three not immediately obvious large rectangular areas: a mauve one at top, a brown one at the left of center, and a yellow one at the right of center. In this and other seemingly unstructured paintings such as

71 *Indian Summer* (1959) and *Lava* (1960), even though the form of the rectangle is not clearly delineated Hofmann appears to have used it almost surreptitiously to organize the space.

Once he found either a color or a formal problem that was particularly interesting or challenging, Hofmann would often

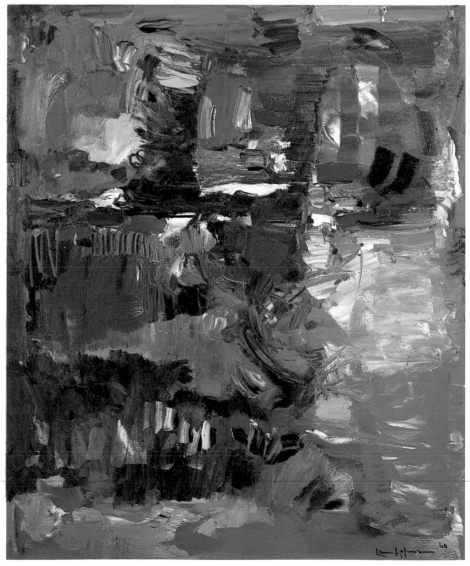

69. *In the Wake of the Hurricane*, 1960
Oil on canvas, 72¼ x 60 in.
University Art Museum, University of California, Berkeley; Gift of the artist

70. *Summer Bliss*, 1960
Oil on canvas, 60⅛ x 72¼ in.
University Art Museum, University of California, Berkeley; Gift of the artist in memory of Worth Ryder

71. *Indian Summer*, 1959
Oil on canvas, 60⅛ x 72¼ in.
University Art Museum, University of California, Berkeley; Gift of the artist

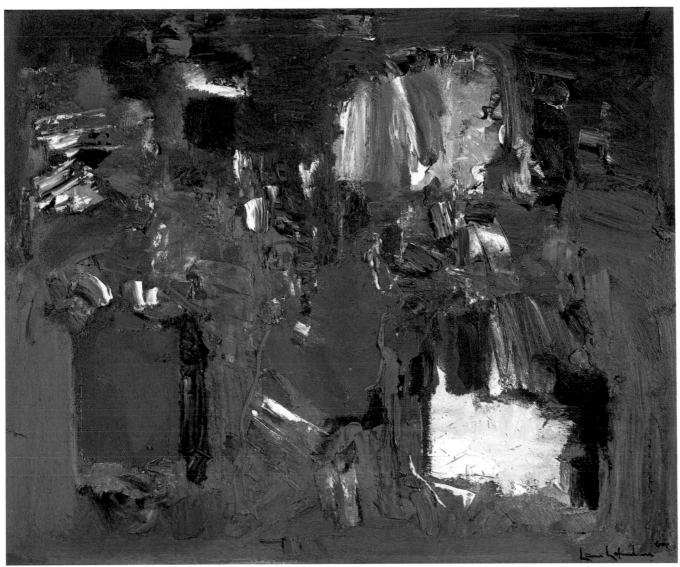

70

71

explore it exhaustively. Certain of these problems reappeared at different stages of his career, sometimes transformed in surprising ways and sometimes almost unrecognizable. Part of the enduring vitality and richness of Hofmann's oeuvre derives from just this ability he had to dip back into his own artistic vocabulary and rediscover elements of an earlier style with new relevance to his work. Hofmann's repeated use of the rectangle best exemplifies this tendency. Once this form was firmly established in his pictorial repertory, he continued until the end of his life to incorporate it into highly experimental compositions, at times following an already established mode of painting and at other times inventing entirely new approaches. To understand the evolution of his geometric style one has only to refer once again to the many paintings and drawings of the 1930s and '40s to see how he dissolved the Provincetown landscape into a profusion of brightly colored planes.

Never content to limit himself to any one way of painting, Hofmann often combined elements from several different styles in one picture. In a group of canvases painted between 1958 and 1962 the puddling and dripping of black paint is the compositional focus. The heavily dripped line in *The Call, Burning Bush, Chimera,* 72, 73

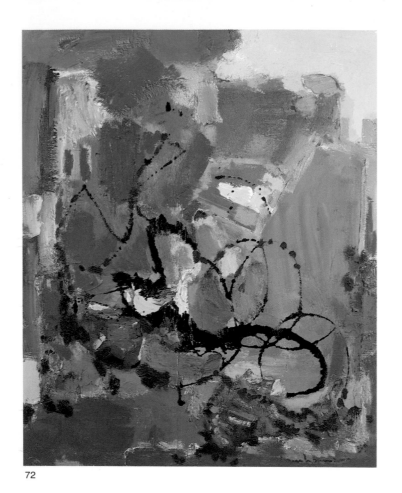

72

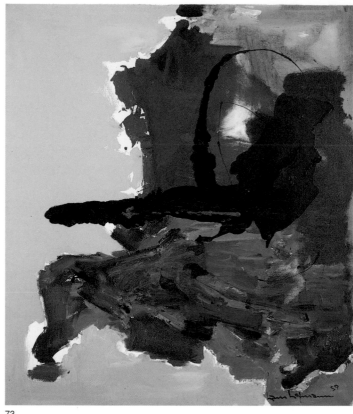

73

74 and *Bald Eagle* has been sensitively laid over a brightly colored
75 painterly ground. In *The Vanquished* a huge puddle of dense black
 paint covering almost one-third of the canvas surface—a more
 extensive area than in any previous composition—has been super-
 imposed on an otherwise fairly typical rectangle painting. Hofmann
 seems to have attempted to integrate this surprising and somewhat
 obtrusive black form with the rest of the composition, however
 unsuccessfully, by extending the heavy black dripping into the
 field of dark green paint at upper right. He had sometimes en-
 countered trouble in his earlier attempts to integrate line with
 Cubist planes; in *The Vanquished* he experienced similar difficulty
 integrating amorphous puddles with rectangles.
 Hofmann became adroit at controlling space with only one or
76 two rectangles. In *Scintillating Red* and *Magnum Opus* (both 1962),
 he floated just two rectangles on dazzling beds of brilliant red
 paint. The two rectangles in *Magnum Opus*—one yellow and the
 other a cobalt blue—are substantial slabs of color. The blue hovers
 to one side of the red field and extends beyond it, so that the
 drama of the single yellow rectangle on the fiery red ground is all
 the more intense. In *Scintillating Red* the two rectangles are merely
 vertical slivers of blue and lime green suspended in the blazing red,
 yet their presence on the otherwise amorphous ground strongly
 asserts the two-dimensionality of the composition, a principle at
 the core of Hofmann's aesthetic.
 Hofmann was a master at thrusting provocative images onto a
 bare white canvas. In a number of compositions the main image

72. *Burning Bush*, 1959
Oil on canvas, 60 x 48 in.
Thomas Marc Futter

73. *Chimera*, 1959
Oil on canvas, 60 x 52 in.
Thomas Marc Futter

74. *Bald Eagle*, 1960
Oil on canvas, 60¼ x 52¼ in.
University Art Museum, University of
California, Berkeley; Gift of the artist

seems to have been achieved by throwing the paint with abandon and letting the form be determined by how the color landed. Many of these paintings from 1960–62, including the *The Phantom, Sailing Phantom, Astral Nebula,* and *The Scorpion,* have either enigmatic or worrisome connotations. Their relatively limited palettes and sparse forms suggest the artist's need for release from the restrictions of his contemporaneous geometric compositions.

 Pastorale (1958), *Abstract Euphony* (1959), *String Quartet* 6

77

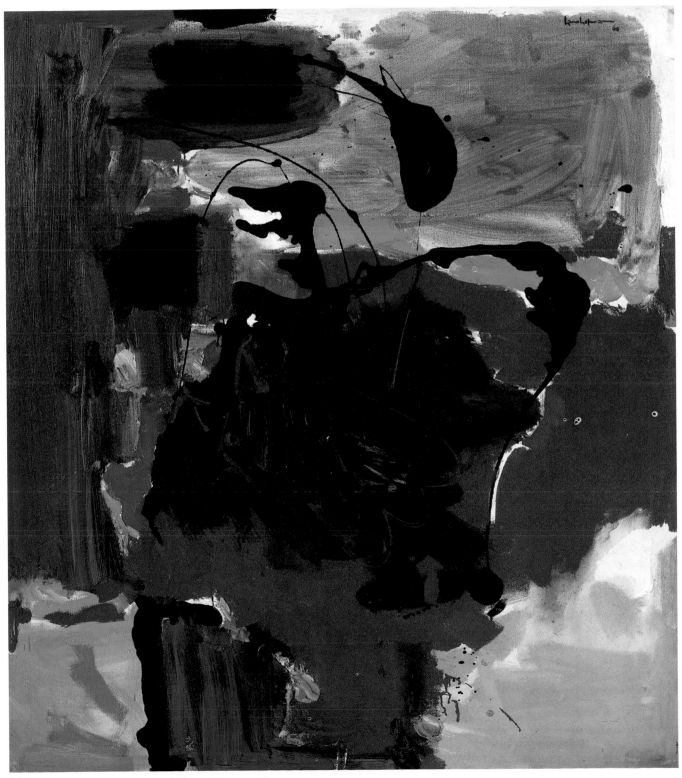

87

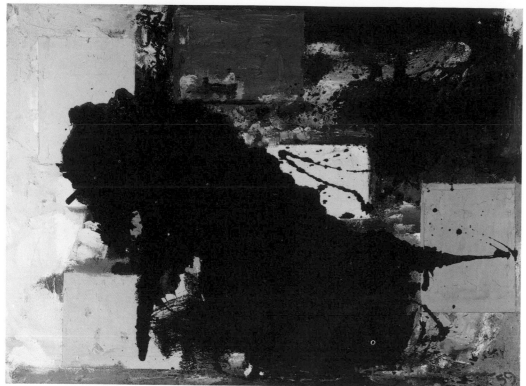

75

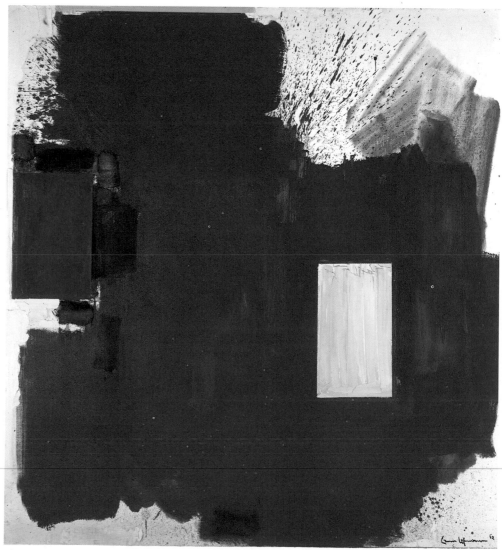

76

(1960), and *Combinable Wall I and II* (1961) are harmonious 78 orchestrations of vivid rectangular components of varied sizes, parallel to and covering the picture plane. Irving Sandler lauded the powerful series of geometric abstractions, of which this group is representative, as "a grand synthesis of Cubist architecture and Fauvist color in an original, nonobjective style."[95] These were referred to varyingly as Hofmann's "slab" or "rectangle" paintings, but the artist called them his "quantum paintings" because "a large area of color would demand only a small area of another to be in 'perfect harmony.'"[96] This musical analogy is an apt one. Hofmann, who claimed that his "ideal" was "to form and to paint as Schubert sings his songs and as Beethoven creates a world in sounds,"[97] also considered these compositions "symphonic," a term he reserved for the few works in the history of art in which "the plastic quality is finally absorbed in the psychological effect of the work."[98] Indeed, his preoccupation with these late rectangle paintings was so extreme that he used their proportions and asymmetry when designing his graveyard plot on the Cape in Truro.

That Mondrian was an omnipresent force behind Hofmann's rectangle compositions has already been noted. Yet the Dutchman's compositions maintain a purity that Hofmann's irrepressible hedon-

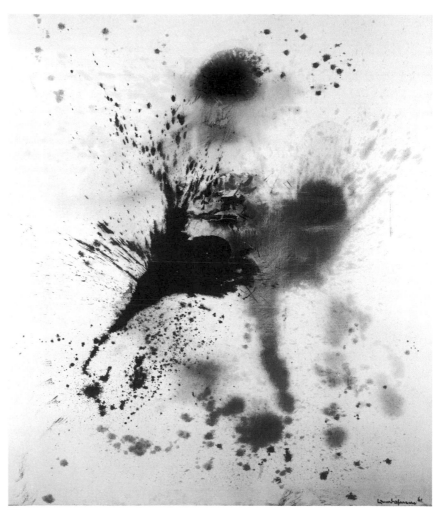

75. *The Vanquished*, 1959
Oil and enamel on canvas, 36⅛ x 48⅛ in.
University Art Museum, University of
California, Berkeley; Gift of the artist

76. *Magnum Opus*, 1962
Oil on canvas, 84⅛ x 78⅛ in.
University Art Museum, University of
California, Berkeley; Gift of the artist

77. *Astral Nebula*, 1961
Oil on canvas, 84 x 72 in.
André Emmerich Gallery, New York

77

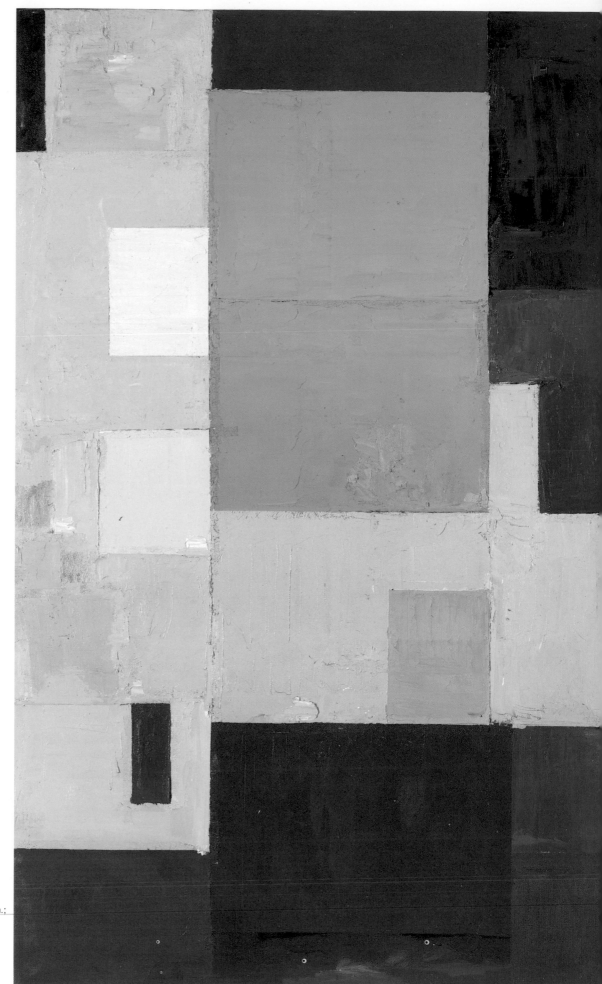

78. *Combinable Wall I and II*, 1961
Oil on canvas, overall: 84½ x 112½ in.;
right side: 84½ x 60¼ in.;
left side: 84½ x 52¼ in.
University Art Museum, University of
California, Berkeley; Gift of the artist

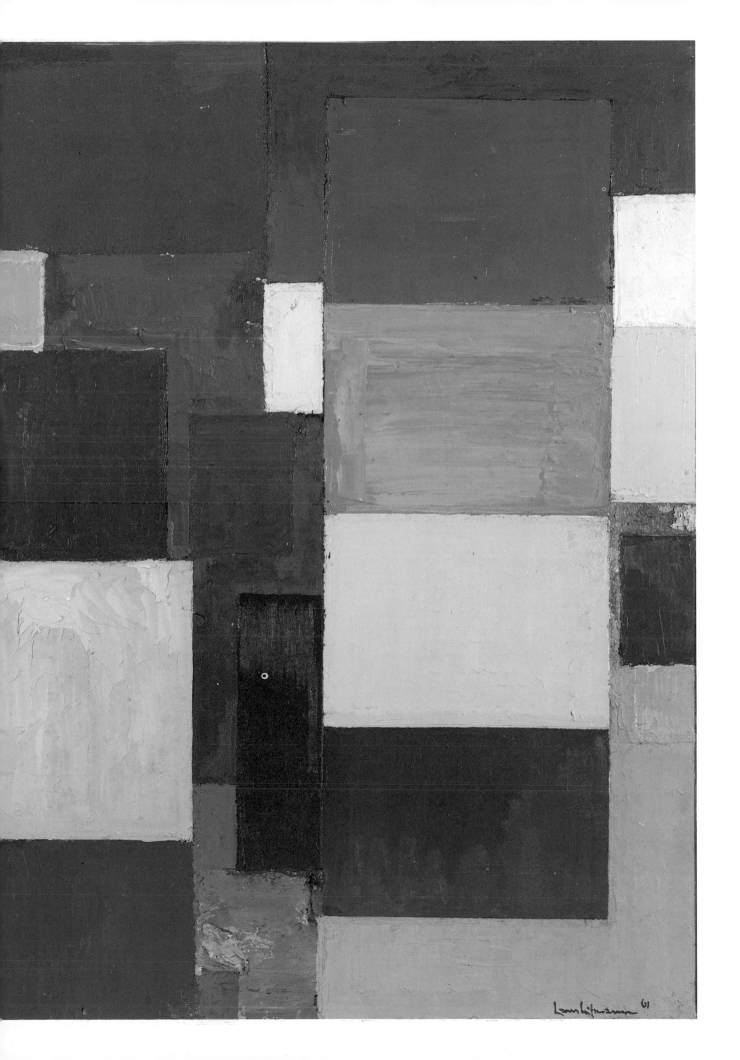

ism would not allow. Hofmann's rectangles, like Mondrian's, are often parallel to the picture plane, and many of his compositions are dominated by a seemingly straightforward, if asymmetrical, arrangement of colored planes; but scrutiny frequently reveals unexpected irregularities. The color may be laid on either in thin washes or in impasto so heavy that the paint crests in peaks. Roughly rectangular components may squeeze between larger shapes to foil an elaborate masterplan. Flourishes of brushwork may blur the edges of certain rectangles, while in other areas a heavy buildup of paint may accentuate the borders with razorlike clarity.

Hofmann's treatment of color was as versatile as his brushstrokes. He might set up jarring relations by juxtaposing two dissonant colors, or he might challenge the viewer to differentiate between two adjoining areas almost indistinguishably similar in value, such as the vertical stack of yellow rectangles along the left border of *Combinable Wall I and II*. Often the glow of a rectangle will mysteriously dim toward its edges, as one more way to obscure a borderline. Each composition represents innumerable adjustments

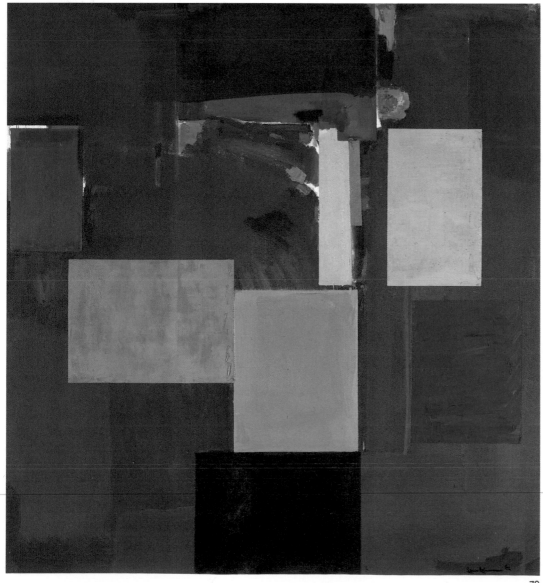

79. *Sanctum Sanctorum*, 1962
Oil on canvas, 84⅛ x 78⅛ in.
University Art Museum, University of
California, Berkeley; Gift of the artist

80. *Silent Night*, 1964
Oil on canvas, 84 x 78¼ in.
University Art Museum, University of
California, Berkeley; Gift of the artist

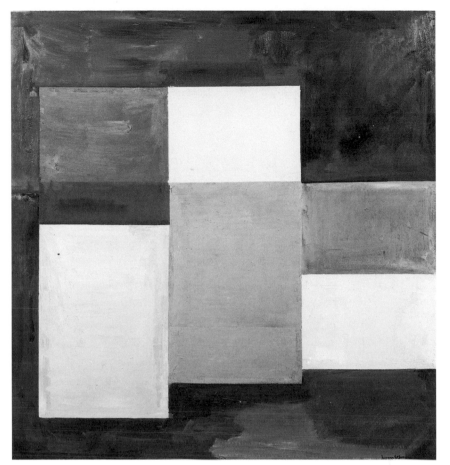

80

of hue and shape. The rich variety of color and surface treatments distinguishes Hofmann's rectangle paintings not only from Mondrian's Neo-plasticism but from all other American geometric painting as well.

Combinable Wall I and II is remarkable for its scale and format. Hofmann constructed this 84½-by-112½-inch painting out of two canvases: a left panel of 84½ by 52¼ inches and a right panel of 84½ by 60¼ inches. This is the only work that Hofmann is know to have assembled in this way. Except for a few earlier examples, including *Undulating Expanse* (1955, 48 by 96 inches) and *Blue on Gray* (1956, 50 by 84½ inches), Hofmann's largest pictures were those of his last few years, such as *Iris* (1964, 72 by 84 inches); *Silent Night* (1964, 84 by 78¼ inches); and *To Miz—Pax Vobiscum* (1964, 78 by 84 inches). Even the canvases in the five-to-eight-foot range that Hofmann preferred in his late years are still relatively modest compared to those by many other New York School painters. De Kooning similarly limited the dimensions of his canvases, and in this way both painters seem to have clung to one aspect of their European easel-painting heritage.

In paintings such as *Sanctum Sanctorum* (1962) and *To Miz— Pax Vobiscum* the number of rectangles has been reduced; the texture of the grounds from which they emerge, although varied, appears restrained; and the rectangles resound with a brilliance equal in force to that of the backgrounds, where color has all but consumed any other compositional considerations. These are two of the many paintings that Hofmann titled with the help of a Latin

79, 85

dictionary, particularly during his last few years. Among others with similarly lofty Latin titles are *Lumen Naturale, Sic Itur Ad Astra, Veluti in Speculum,* and *Fiat Lux.*

93
80 Hofmann continued to refine his compositions. In *Silent Night* the rectangles are restricted not only in number but also in hue. The yellow and ocher rectangles are clustered in this nighttime reverie like a constellation of stars in a clear blue sky. Rather than relying on bright contrasts of color for effect, these planes differ from each other in intensity, not hue. Just as the stars in the sky nearer to us seem to shine more brightly than those farther away, the brightest "star" in this grouping is an orange rectangle in the center of the bottom edge. In spite of their closeness in hue, each rectangle is richly varied in texture. The rectangle in the center at the top has bands three to four inches wide that appear to have been laid down with a flat instrument; in the yellow rectangle at bottom left the paint looks as if Hofmann applied it with a stiff brush, each bristle of which left its imprint. The yellow rectangle at bottom right combines both these effects. The artist had often reminded his students that "simplicity means pureness not poorness." *Silent Night* epitomizes the wisdom of this dictum.

81, 82 Similarly, in *Lucidus Ordo* (1962), *Polyhymnia* (1963), and *Pendular Swing* (1964), relatively few rectangles are superimposed over amorphous stains and washes of paint, so that the solidity of the rectangles sharply contrasts with the delicacy of the grounds.

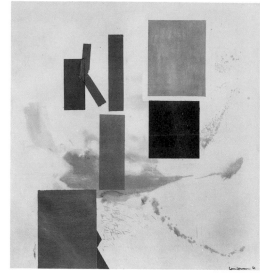

81

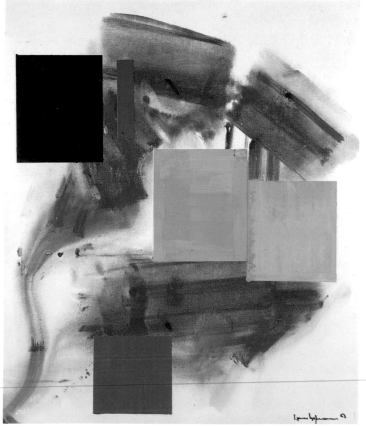

82

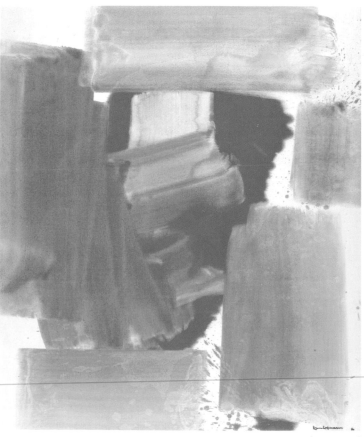

83

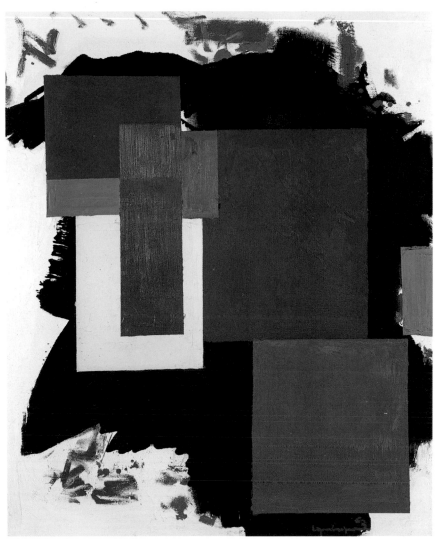

84

The insertion of narrow slices of color in these compositions counter-balances the weightiness of the larger, more ponderous slabs. Similar juxtapositions of differently proportioned rectangles had been used highly effectively to punctuate the space in earlier, more densely painted compositions, such as the magnificent *The Golden Wall* 8 (1961) and *Leise Zeiht Durch Mein Gemut, Liebliches Gelaute* ("A Peaceful Song Passes Softly through My Soul," 1961).

Hofmann equivocated about whether pigment applied in thin washes needed the reinforcement of rectangles or whether washy areas could stand alone, as in the impressive *Agrigento*. In *Agri-* 83 *gento, Staccato in Blue, Fall Foliage*, and other paintings of 1961–62 that are composed of large, irregular blocks of fairly uniform color, Hofmann explored one way of escaping the confines of his more strictly rectangular compositions while exploring the space-making potential of related forms. The restriction of the palette to only one color in *Agrigento* announces his new interest in monochrome canvases. In the early 1960s, as in 1947, Hofmann limited himself to only one or two colors in a group of paintings. The stained burnt-umber blocks that constitute the pictorial framework of *Agrigento* appear to have been made by moving a wide, flat object

covered in paint across the picture surface. Hofmann seems to have been concerned here as much with how he could flood the canvas with saturated color as he was with the movement generated by the jostling of loosely defined planes. In *Agrigento* the energy of Franz Kline's forms and the monumentality of Clyfford Still's architectonic compositions have been infused with the seductiveness of Hofmann's sanguine color.

Hofmann was able to translate even the most painful emotions into paint on canvas. The elegiac *In the Vastness of Sorrowful Thoughts* (1963) was painted after the death of his wife, Miz, from unanticipated complications following gall bladder surgery in the spring of 1963. The solemnity of the primarily black blotches is alleviated only by the bloodlike gushing of the red splashes and trails of paint. Dramatically mournful, *In the Vastness of Sorrowful Thoughts* is strikingly different in spirit from the sensual exuberance infusing so many other of the artist's contemporaneous works. Hofmann recalled Miz as his "muse," who "lived with my art and for my art."[99] Yet he did not always express his great sorrow over her loss in solemn tones. Bultman remembered his astonishment when he visited Hofmann shortly after Miz's death and found him at work on a magnificently colorful canvas. When Bultman remarked to the artist how surprised he was to see him able to create such a radiant painting in the midst of his mourning, Hofmann replied that the painting expressed his "negative ecstasy." *To Miz—Pax Vobiscum*, which was painted the year after her death, is saturated with high-keyed reds and blues, providing an exultant commemoration of her life.

86

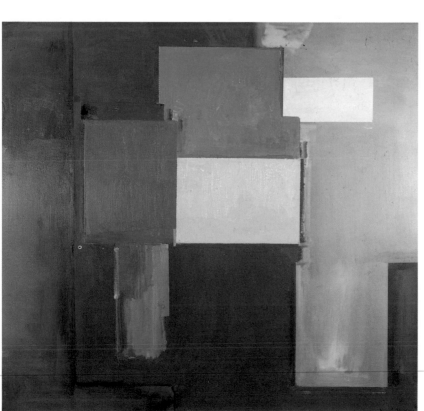

85

85. *To Miz—Pax Vobiscum*, 1964
Oil on canvas, 78 x 84 in.
Senator and Mrs. John D. Rockefeller IV

86. *In the Vastness of Sorrowful Thoughts*, 1963
Oil on canvas, 78⅛ x 84 in.
University Art Museum, University of California, Berkeley; Gift of the artist

87. *Lust and Delight*, 1965
Oil on canvas, 84¼ x 60¼ in.
The Metropolitan Museum of Art, New York; Promised gift of Renate Hofmann

88. *The Castle*, 1965
Oil on canvas, 60⅛ x 40⅛ in.
University Art Museum, University of California, Berkeley; Gift of the artist

After Miz's death, Robert and Helga Hoenigsberg, who were Hofmann's neighbors and close friends, introduced the artist to Renate Schmitz, a strikingly attractive German girl in her late twenties who lived in their apartment complex. Not long afterward, in 1964, the two were married, and Hofmann named one of his greatest suites of painting, the Renate Series, in her honor. Like the late Titian, Monet, and Matisse, Hofmann experienced an efflorescence of creative activity in his last years virtually unsurpassed at any previous time in his career. The eleven paintings in this series sum up the expanse and vigor of his artistic vision. The delicate, murky stains of *Little Cherry*, the carefree mirth of *Lust and Delight*, the strong architectonic resonance of *Rhapsody*—all were painted in the summer of 1965. It is as if the artist, then eighty-five years old, intended these paintings (which he wanted to remain as a group; eight of them are currently on extended loan to the Metropolitan Museum of Art and one is in its permanent collection) as lasting testimony to the staggering amplitude of his artistic accomplishments.

In most compositions where Hofmann used clearly defined rectangles, they seem to maintain a fairly rigid vertical-horizontal

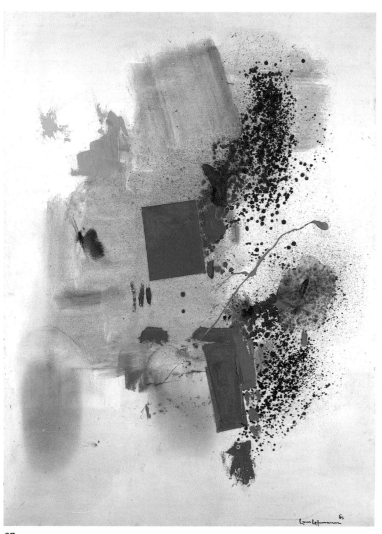

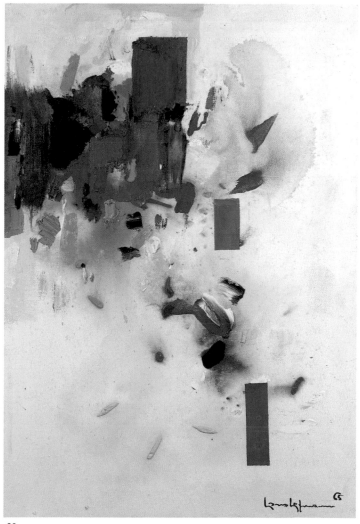

87

88

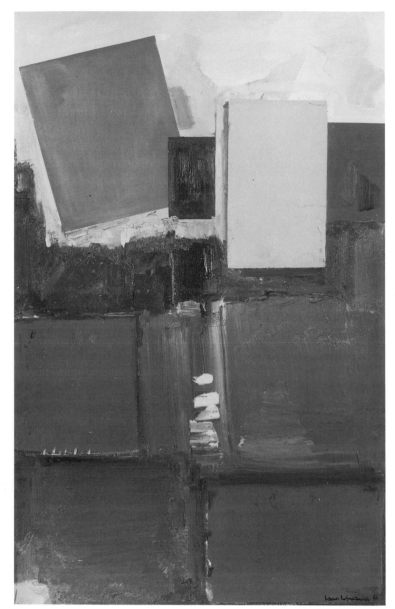

89

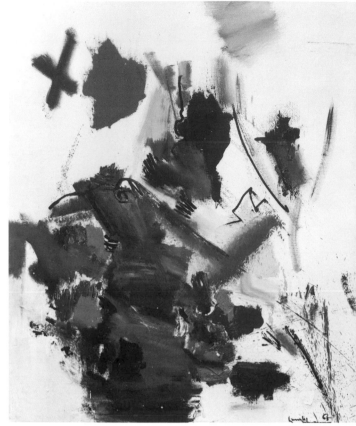

90

orientation in spite of their actual irregularities. In *Conjunctis*
89 *Viribus* (1963) and *Imperium in Imperio* (1964) he flirted with
tilting the rectangles to one side, an experiment he continued until
the end of his life in such paintings as *Lust and Delight* (1965) and
Heraldic Call (1965), both in the Renate Series. Although nearly
eclipsed by his more commanding rectangle paintings, another
group of pictures painted in Hofmann's last few years suggests a
lighthearted mood of revelry and sensual delight. Restrained in
their use of pigment and combining only a few rectangles with
88, 97 eloquent gestural markings, *The Castle*, *Frolocking* (sic), and *Joy
Sparks of the Gods II* celebrate the very act of painting.

 Not even a trace of the familiar rectangular shape remains in a
number of Hofmann's other late paintings. Both the variable tempo
of the paint application within a very small area in these composi-
tions and the jubilant improvisation recall the abrupt changes and
the rejoicing mood of many passages in Bach's Brandenburg
Concertos, which Hofmann listened to over and over again while

89. *Imperium in Imperio*, 1964
Oil on canvas, 84⅛ x 52 in.
University Art Museum, University of
California, Berkeley; Gift of the artist

90. *Struwel Peter*, 1965
Oil on canvas, 72⅛ x 60¼ in.
University Art Museum, University of
California, Berkeley; Gift of the artist

91. *Maiden Dance*, 1964
Oil on canvas, 60⅛ x 52⅛ in.
University Art Museum, University of
California, Berkeley; Gift of the artist

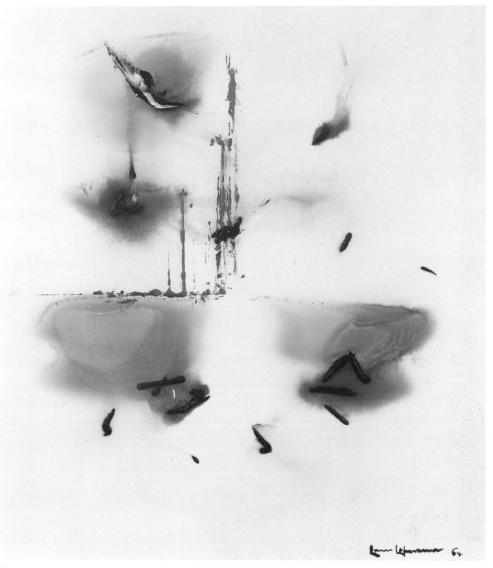

91

painting. Some of these pictures display with particular adroitness the hand and wrist agility of the artist in integrating graphic elements with the sheerest stains. Leaving large areas of the canvas bare in *Mirth, Morning Mist, Struwel Peter,* and *Maiden Dance,* Hofmann applied a private notational system of dots, crosses, stains, and smears of varicolored paint. One is struck by the seeming rapidity with which he applied the paint to *Struwel Peter.* The delicate blue stains of the sparsely painted *Maiden Dance* contrast with thick blobs and squiggles of paint squeezed directly from the tube. Hofmann's elaboration of otherwise almost barren compositions with paint applied in such a manner manifests the unpredictable and adventuresome spirit that led him, as he confessed to Elaine de Kooning, to "use a hundred tubes for one picture, or one tube for a hundred pictures; lots of medium or none at all."[100]

In some of the late paintings without rectangles the surfaces are lavishly covered with paint, as if Hofmann's lust for pigment was insatiable. The titles of a number of these pictures indicate his

90, 91

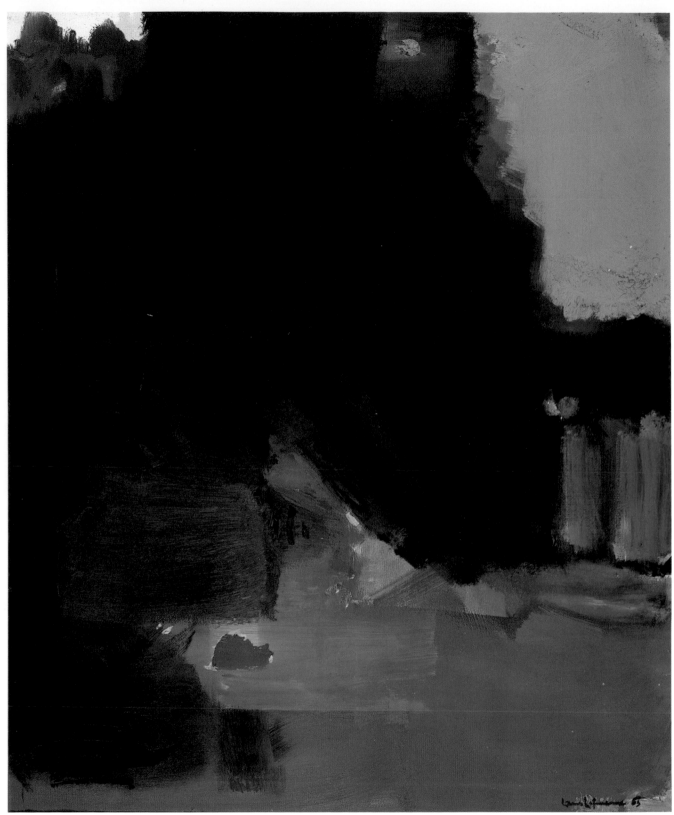

92

unfaltering observation of nature and his attempts to portray various natural phenomena. A masterpiece of painterly bravura, *And Thunderclouds Pass* (1961) has a powerful resonance that builds from the hot magenta and orange at the bottom until it swells to a crescendo in the somber black above. In *Nocturnal Splendor* (1963), Hofmann celebrated the wonders of the night rather than its more

95

92

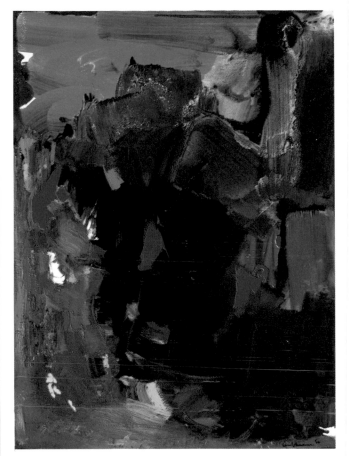

98

96

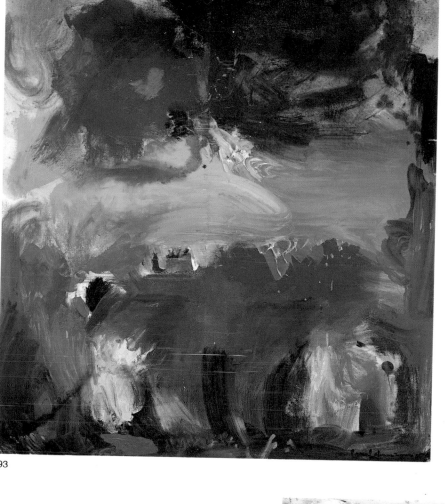

93

Ho
hund
chall
worl
with
abilit
and e
holy
the F

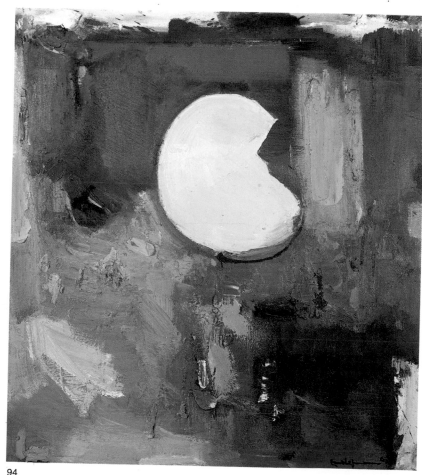

94

sinister aspects. The r...
yellows is intensified b...
mately one-half of the...
(1961) Hofmann bold...
masterful juxtaposition...
against the depth of a...
yellow in *Salut au Mat*...
the sky's joyful celebra...

94 The incised yellow f...
also exults in the respl...

97

palette but in his wardrobe as well. His favorite painting outfit (when he wasn't painting in the nude) consisted of an open-necked short-sleeved shirt and baggy pants of cobalt blue. When he finished for the day, there was paint not only on the picture surface but also all over Hofmann himself, substantiating his repeated claim that in the studio he "swimmed in color."[4] As part of his cleaning ritual every trace of paint was removed from the palette, no matter how much remained unused. Each brush was dipped individually into turpentine and then washed in a mixture of warm water and Tide detergent. He continued his meticulous regime until everything in the studio was restored to its original condition. This process reflected the compelling need for order that coexisted with Hofmann's seemingly irreconcilable urge for spontaneity and improvisation.

Until 1947 it was Hofmann's custom to paint on plywood panels, although he also used upsom board and poster board. Many of his paintings on these surfaces were double-sided, not necessarily because of any economizing, but often because of simple carelessness: once Hofmann started painting he impulsively grabbed whatever surface was in reach. The majority of these paintings were in oil, which was thinly applied with either brushes or a palette knife, although Hofmann sometimes combined in one painting several different types of media such as oil, casein, duco, enamel, gouache, and india ink. He prepared the panel surfaces himself, using up to eight coats of gesso on each side, under the unfortunately false assumption that he was a master of this preparatory technique. As a result he compounded many of the conservation problems that tend to arise with works on such fragile supports.[5]

From sometime in 1947 until the early 1950s, when he began using a good quality linen as his principal painting support, Hofmann worked primarily on heavy duck. Whatever the surface, he continued to prepare the "raw canvas himself with flat white to close the pores, then a gesso ground, which he maintains is the only ground that does not turn yellow."[6] Also in the early 1950s, he began using alkyd white interior house paint instead of glue gesso as his principal ground. Fortunately, in most instances he applied animal-glue size to the linen before the house paint. Hofmann realized that this preparation technique took time, but as he explained to art critic Katharine Kuh: "I simply can not paint on commercial canvas. Nothing will come out. So you see, I've been working on a canvas for a long time before I start to paint it."[7]

Except for the *lichtdrucke* he had made in Germany and two editions of silkscreen prints done in the United States, Hofmann concentrated on drawing and painting. He did, however, fulfill two commissions for mosaics. The first is a striking mosaic mural of approximately 1,200 square feet that covers all four sides of a freestanding elevator shaft in the lobby at 711 Third Avenue in New York City; the building was designed by the noted architect William Lescaze and completed in 1957. The following year Hofmann designed a block-long mosaic for the exterior of the New York School of Printing at 439 West Forty-ninth Street (now the High School of Graphic Communication Arts), which was designed by Kelly and Gruzen, Architects. Both of these works are

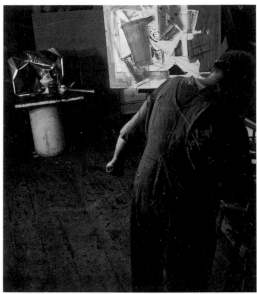

104

105

106

still in place. The mural at 711 Third Avenue is a particularly stunning design of bright swaths and bold rectangles of color, which startles many first-time visitors to the stark modern building, where it confronts them as soon as they walk through the entrance. The success of Hofmann's mosaics may be partially attributed to his ease in translating into stone the tesseralike color effects that flickered in paintings such as *Scintillating Space* and *Orchestral Dominance in Green*.

The only published record of Hofmann's painting technique is the perceptive article "Hans Hofmann Paints a Picture," written by Elaine de Kooning for *Artnews* as part of her series on artists in their studios. This article, which describes in detail how Hofmann painted *Fruit Bowl Transubstantiation #1* of 1950, is illustrated with excellent photographs by Rudolph Burckhardt. Although Hofmann protested that he wanted to deny theory when painting, de Kooning rightly observed that "any discussion of Hofmann's technique must revolve around his theories. 'Technique is always the consequence of the dominating concept; with the change of concept, technique will change.'"[8] This statement helps explain the variations in Hofmann's technique from painting to painting, with some surfaces thickly troughed with paint and others thin and sparse.

Hofmann began *Fruit Bowl Transubstantiation #1* with an arrangement of three apples, an ashtray, and a backdrop of silver wrapping paper. By 1950 he "no longer [had] the patience to work with pen, pencil, or crayons,"[9] and all his drawings were executed with a brush. His major concern was how to create an illusion of deep space without "destroying the surface." Before tackling this still life on canvas, he made sketches in black oil on paper in order to establish the depth of his subject. Although he drew these sketches before painting, the composition seemed to evolve completely independently of them, and he retained from the sketches only one vertical line to the left of center in his final painting.

As de Kooning reported, Hofmann began this composition by picking "up a small soft-haired brush, dipped in turpentine, then in blue and yellow paint and rapidly established the 'architecture' of the still life with fine, fluid lines in a drawing on canvas that actually evokes a blueprint."[10] Next he applied flat areas of color, using a crumpled piece of gauze. As Hofmann painted one section, the thin paint dripped down and the artist did not attempt to control the dripping, as he often did in other paintings by working on the floor and tilting the canvas from side to side. He was still not satisfied with the composition:

Forms were put down and wiped away as the impulse of the drawing swung from side to side: a stroke shooting to the left was balanced by another to the right. He scraped off unwanted colors with a palette knife; picked up one of the paint-soaked pieces of gauze that had accumulated on his palette table, wrung it out so that it was almost dry, dragged it across the coarse-grained duck for a dry-brush effect; dipped another piece into turpentine (the only medium used for this picture) and washed on a glaze. As the composition became more complex, the impasto was laid on more thickly, sometimes heightening a color, sometimes contra-

104. Hans Hofmann at work on *Fruit Bowl Transubstantiation #1*, 1950. Photograph by Rudolph Burckhardt.

105. Hans Hofmann in his studio, 1950. Photograph by Rudolph Burckhardt.

106. Hans Hofmann with sketches for *Fruit Bowl Transubstantiation #1*, 1950. Photograph by Rudolph Burckhardt.

109

1918 After the war his school begins to be known abroad and attracts foreign students such as Worth Ryder, Glenn Wessels, Carl Holty, Louise Nevelson, Vaclav Vytlacil, Alfred Jensen, and Ludwig Sander. Has little time to paint but draws continually.

1922–29 Takes students on summer trips: Tegernsee, Bavaria, 1922; Ragusa, 1924; Capri, 1925–27; St. Tropez, 1928–29. His summer expeditions are interspersed with frequent trips to Paris.

1929 Marries Miz Wolfegg, twenty-nine years after their first meeting. Has a group of his drawings reproduced as *lichtdrucke*, a photographic process.

1930 Worth Ryder, chairman of the department of art, University of California, Berkeley, invites Hofmann to teach in the summer session. Glenn Wessels accompanies him on the trip to America; they stop to visit former students and friends in Chicago and Minneapolis. Hofmann

executes a series of drawings inspired by the American countryside and industry. Winter—returns to Munich.

1931 Spring—teaches at Chouinard School of Art, Los Angeles. Summer—returns to Berkeley. At University of California writes first version of "Form und Farbe in der Gestaltung" (translated by Glenn Wessels as "Creation in Form and Color: A Textbook for Instruction in Art"), an extensive exposition of ideas he had been developing since 1915.

1932 Moves to New York, where he lives in the Barbizon Plaza Hotel (Miz stays behind in Germany). Summer—begins teaching at the Art Students League, where Burgoyne Diller, Rae Eames, Harry Holtzman, Lillian Kiesler, Mercedes Carles Matter, George McNeil, and Irene Rice Pereira are among his first students.

1933 Summer—is guest instructor at Thurn School of Art, Gloucester, Massachusetts (Ernest Thurn had been his student in Munich).

c. 1904–8 Arrives in Paris just as the Fauve movement gets under way. Attends evening sketch classes at Colarossi's and the Ecole de la Grande Chaumière. Frequents the Café du Dôme, favorite haunt of artists and writers. Subsequently becomes part owner, with Richard Goetz, of Georges Seurat's *Le Cirque*. Jules Pascin and Robert Delaunay become his good friends; friendship with Delaunay proves particularly important to his development as a colorist. Paints Cubist still lifes, landscapes in the Luxembourg Garden, and figurative pieces. A number of these are sent to Phillip Freudenberg in Berlin but subsequently disappear. Miz designs scarves with Sonia Delaunay; Hans and Robert collaborate on patterns for Sonia's fashions.

1908 Included in group exhibition at the New Secession, Berlin (and again in 1909).

1910 First one-man exhibition held at Paul Cassirer Gallery, Berlin.

1914 Spring—sister's illness brings him back to Munich. Summer—while he is vacationing on the Ammersee, World War I is declared; earliest work left in Paris is never seen again. Lung condition keeps him out of the army. War terminates Freudenberg's financial assistance, and Hofmann decides to teach.

1915 Spring—opens School for Modern Art in the Munich suburb of Schwabing.

109. *Untitled* (student drawing), 1898
Pencil on paper, 8 x 11½ in.
André Emmerich Gallery, New York

110. *Rope Swinger*, 1962
Oil and enamel on canvas, 60⅛ x 48⅛ in.
University Art Museum, University of
California, Berkeley; Gift of the artist

110

Fall—opens a school at 444 Madison Avenue, New York.

1934 Goes to Bermuda for a few months and returns with a permanent visa. Summer—teaches again at the Thurn School. Fall—Hans Hofmann School of Fine Arts opens at 137 East Fifty-seventh Street, New York.

1935 Summer—opens his summer school in Provincetown, Massachusetts. Starts to paint regularly again.

1936 Hofmann School moves to 52 West Ninth Street, where it remains until moving to its permanent location at 52 West Eighth Street, in 1938. Greatly impressed by the *Cubism and Abstract Art* exhibition at the Museum of Modern Art, New York.

1938–39 Delivers a well-attended lecture series at his Eighth Street school.

1939 Miz Hofmann comes to the U.S., bringing with her some of her husband's work, some Biedermeier furniture, and some of their works by other artists.

1941 Becomes U.S. citizen. Delivers address during annual meeting of the American Abstract Artists at the Riverside Museum.

1942 Lee Krasner, formerly a Hofmann student, introduces Hofmann to Jackson Pollock.

1944 First one-man exhibition in New York held at Peggy Guggenheim's Art of This Century gallery: oils, gouaches, drawings. Meets critic Clement Greenberg. Begins working almost exclusively indoors after a hernia operation. Hans and Miz move into a one-room fifth-floor walkup apartment on Fourteenth Street.

1945 Included in *Contemporary American Painting* at the Whitney Museum of American Art, New York.

1947 Addison Gallery of American Art, Andover, Massachusetts, acquires *Black Demon*. November—his first exhibition at Kootz Gallery, New York, opens. Hofmann develops close friendship with Sam Kootz.

1948 Large retrospective organized by the Addison Gallery of American Art, the first major one-man exhibition given by a museum to an Abstract Expressionist. *Search for the Real and Other Essays*, the first monograph on an Abstract Expressionist, is published.

1949 January—travels to Paris to attend solo exhibition at Galerie Maeght, Paris; visits studios of Picasso, Braque, Brancusi, and Miró. Helps Fritz Bultman and Weldon Kees organize

Forum '49, a summer-long series of lectures, panels, and exhibitions in Provincetown at the Gallery 200.

1950 April—participates in a three-day symposium at Studio 35 with William Baziotes, James Brooks, Willem de Kooning, Herbert Ferber, Theodoros Stamos, David Smith, and Bradley Walker Tomlin. Joins the so-called Irascibles (Baziotes, de Kooning, Adolph Gottlieb, Robert Motherwell, Barnett Newman, Pollock, Richard Pousette-Dart, Ad Reinhardt, Mark Rothko, Clyfford Still, and Tomlin) in writing an open letter to Roland Redmond, president of the Metropolitan Museum of Art, protesting the exclusion of the avant-garde from a large upcoming exhibition of American art. Walker Art Center purchases *Elegy*, 1950.

1951 October—juries *60th Annual American Exhibition*, Art Institute of Chicago, with Aline Louchheim and Peter Blume.

1955 Small retrospective exhibition selected by Clement Greenberg held at Bennington College, Bennington, Vermont.

1956 Designs mosaic mural for the lobby of 711 Third Avenue, New York.

1957 Retrospective exhibition held at the Whitney Museum of American Art.

1958 Closes his schools to devote himself full time to painting. Moves his studio to the school quarters at 52 West Eighth Street. Designs mosaic mural for the exterior of the New York School of Printing, 439 West Forty-ninth Street.

1960 Included in *XXX Venice Biennale* with Philip Guston, Franz Kline, and Theodore Roszak. Travels to Europe.

1961 Sends a letter to the *New York Times* protesting the conservatism of critic John Canaday; among others signing are de Kooning, Gottlieb, Newman, David Smith, Motherwell, Thomas B. Hess, Sam Hunter, Harold Rosenberg, Irving Sandler, and Meyer Schapiro.

1962 Receives honorary degree from Dartmouth College, Hanover, New Hampshire.

1963 Spring—Miz Hofmann dies. Fall—retrospective exhibition held at the Museum of Modern Art, New York, organized by William Seitz. Signs agreement to give forty-five paintings to the University of California, Berkeley, and to fund construction of a gallery in his honor.

1964 Marriage to Renate Schmitz inspires the Renate Series. Receives honorary degree from University of California, Berkeley.

1966 February 17—Hans Hofmann dies.

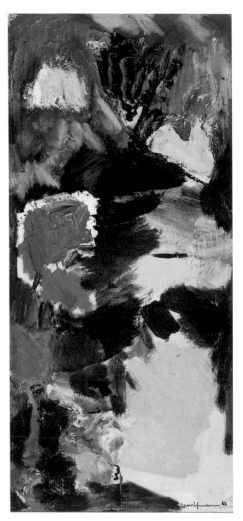

111. *Song of the Philomel*, 1963
Oil on canvas, 84 x 36 in.
University Art Museum, University of California, Berkeley; Gift of the artist

Exhibitions

of Modern Art tour to Michigan State University, East Lansing; Akron Art Institute, Akron, Ohio; Hunter Gallery of Art, Chattanooga, Tennessee; Goucher College, Towson, Maryland; Joe and Emily Lowe Art Gallery, University of Miami, Coral Gables, Florida.

Hans Hofmann, Museum of Modern Art, New York, September 11–November 28, and tour to Rose Art Museum, Brandeis University, Waltham, Massachusetts; Isaac Delgado Museum of Art, New Orleans; Albright-Knox Art Gallery, Buffalo, New York; University of California, Berkeley; Gallery of Modern Art, Washington, D.C.; Museo de Arte Moderno de Buenos Aires; Museo de Bellas Artes, Caracas; Stedelijk Museum, Amsterdam; Galleria Civica d'Arte Moderna, Turin; Württembergischer Kunstverein, Stuttgart; Amerika Haus, Hamburg; Städtisches Kunsthaus, Bielefeld.

1964

Hans Hofmann: Paintings, 1963, Kootz Gallery, New York, February 18–March 7.

Recent Gifts and Loans of Paintings by Hans Hofmann, Power House Gallery, University of California, Berkeley, May 11–June 7.

Hans Hofmann: Oils, American Art Gallery, Copenhagen, April 18–May 9.

1965

Hans Hofmann, 85th Anniversary: Paintings of 1964, Kootz Gallery, New York, February 16–March 6.

1966

Hans Hofmann, Kootz Gallery, New York, February 1–26.

Hans Hofmann: 21 Paintings, Stanford Art Museum, Stanford University, June 22–August 17.

1967

Hans Hofmann, André Emmerich Gallery, New York, January 21–February 9.

1968

Hans Hofmann, André Emmerich Gallery, January 6–31.

Hans Hofmann: Paintings, Richard Gray Gallery, Chicago, January 31–March 2 (solo exhibitions also held in 1972, 1980).

21 Hofmanns from Berkeley, Honolulu Academy of the Arts, March 29–May 5.

Paintings by Hans Hofmann, La Jolla Museum of Art, La Jolla, California, May 25–June 30.

1969

Hans Hofmann: Ten Major Works, André Emmerich Gallery, January 11–30.

Hans Hofmann, David Mirvish Gallery, Toronto, March 22–April 15. Solo exhibitions also held in 1972, 1973, 1977.

1970

Hans Hofmann: Paintings of the 40s, 50s and 60s, André Emmerich Gallery, January 3–22.

Hans Hofmann: Paintings, Waddington Galleries II, London, June 9–July 4.

1971

Hans Hofmann, André Emmerich Gallery, January 9–February 3.

1972

Hans Hofmann, André Emmerich Gallery, January 8–27.

Hans Hofmann: The Renate Series, Metropolitan Museum of Art, New York, October 16–December 31.

Hans Hofmann, Janie C. Lee Gallery, Dallas, December.

1973

Hans Hofmann: 10 Major Works, André Emmerich Gallery, January 6–24.

Hans Hofmann: Works on Paper, André Emmerich Gallery, September 15–October 11.

Hans Hofmann: 52 Works on Paper, Museum of Art, University of Michigan, Ann Arbor, October 15–November 15, and International Exhibitions Foundation tour to University Art Museum, University of California, Berkeley; Arkansas Art Center, Little Rock; Tyler Museum of Art, Tyler, Texas; Palm Springs Desert Museum, Palm Springs, California; Wichita State University, Wichita, Kansas.

1974

Hans Hofmann: Paintings, 1936–1940, André Emmerich Gallery, January 5–24.

Hans Hofmann: A Colorist in Black and White, Currier Gallery of Art, Manchester, New Hampshire, October 15–November 15, and International Exhibitions Council tour to Georgia Museum of Art, Athens; Palm Springs Desert Museum, Palm Springs, California (partial listing).

1975

Hans Hofmann: 108 Works, Bowers Museum, Santa Ana, California, April 15–May 15.

Hans Hofmann: A Selection of Late Paintings, André Emmerich Gallery, May 17–June 17.

1976

Hans Hofmann: The Years 1947–1952, André Emmerich Gallery, April.

Hans Hofmann: A Retrospective Exhibition, Hirshhorn Museum and Sculpture Garden, Smithsonian Institution, Washington, D.C., October 14–January 2, 1977, and tour to Museum of Fine Arts, Houston. Organized with the Museum of Fine Arts, Houston.

1977

Provincetown Landscapes, André Emmerich Gallery, January 8–26.

1978

Hans Hofmann: Drawings, 1930–1944, André Emmerich Gallery, December 10–January 11, 1979.

1979

Hans Hofmann: Provincetown Landscapes, 1941–1943, André Emmerich Gallery, January 6–31.

Hans Hofmann Drawings, Harriman College, Harriman, New York, April 25–May 1.

Hans Hofmann: Works on Paper, Marianne Friedland Gallery, Toronto, November 3–24. Solo exhibitions also held in 1981, 1982, 1984.

1980

Hans Hofmann: Private-Scale Paintings, André Emmerich Gallery, January 12–February 6.

Hans Hofmann: Provincetown Scenes (shown jointly with *Hans Hofmann as Teacher: Drawings by His Students*), Provincetown Art Association, Provincetown, Massachusetts, August 1–October 12.

Hans Hofmann: The Renate Series, Metropolitan Museum of Art, December 2–January 31, 1981.

Hans Hofmann, Centennial Celebration, Part I: Major Paintings, André Emmerich Gallery, December 13–January 13, 1981.

1981

Hans Hofmann, Centennial Celebration, Part II: Works on Paper, André Emmerich Gallery, January 17–February 14.

1982

Hans Hofmann: The Late Small Paintings, André Emmerich Gallery, January 7–January 30.

Hans Hofmann, 1880–1966: An Introduction to His Paintings, Edmonton Art Gallery, Edmonton, Canada, July 9–September 5.

1983

Hans Hofmann: Paintings on Paper, 1958–1965, André Emmerich Gallery, January 6–29.

1984

Hans Hofmann: Explorations of Major Themes: Pictures on Paper, 1940–1950, André Emmerich Gallery, January 7–February 4.

1985

Major Paintings, André Emmerich Gallery, January 5–26.

Selected Group Exhibitions

1908

New Secession, Berlin.

1909

New Secession, Berlin.

1943

Fifty Years on 57th Street, Art Students League, New York, February 7–28.

1944

Abstract and Surrealist Art in the United States, Cincinnati Art Museum, February 8–March 12, and tour.

Forty American Moderns, Gallery 67, New York, December 4–30.

1945

A Problem for Critics, Gallery 67, May 14–July 7.

Annual Exhibition of Contemporary American Painting, Whitney Museum of American Art, New York, May 17–June 17. Included in all subsequent Whitney painting annuals.

The Ideographic Picture, Betty Parsons Gallery, New York, January 20–February 8.

1948

Contemporary American Painting and Sculpture, University of Illinois, Urbana, February 29–March 28. Also included in 1950, 1951, 1952, 1953, 1955, 1957, 1959, 1961, 1963, 1965.

1949

Forum '49, Gallery 200, Provincetown, Massachusetts, summer.

The Intrasubjectives, Kootz Gallery, New York, September 14–October 3.

1950

The Muralist and the Modern Architect, Kootz Gallery, New York, October 3–23.

1951

Abstract Painting and Sculpture in America, Museum of Modern Art, New York, January 23–March 25.

Ninth Street Show, 60 East Ninth Street, New York, May 21–June 10.

Intimate Media, Kootz Gallery, New York, May.

40 American Painters, 1940–1950, University of Minnesota, Minneapolis, June 4–August 30.

60th Annual American Exhibition of Paintings and Sculpture, Art Institute of Chicago, October 25–December 16.

American Vanguard Art for Paris, Sidney Janis Gallery, New York, December 26–January 5, 1952.

1952

Expressionism in American Painting, Albright Art Gallery, Buffalo, New York, May 10–June 29.

Pittsburgh International Exhibition of Contemporary Painting, Carnegie Institute, Pittsburgh, October 16–December 14. Also included in 1958, 1964.

1953

Four Abstract Expressionists, Walker Art Center, Minneapolis, February.

1954

Nine American Painters Today, Sidney Janis Gallery, January 4–23.

1958

Nature in Abstraction: The Relation of Abstract Painting and Sculpture to Nature in Twentieth-Century American Art, Whitney Museum of American Art, January 14–March 16, and tour.

1960

XXX Venice Biennale, June 18–October.

Paths of Abstract Art, Cleveland Museum of Art, October.

1961

American Abstract Expressionists and Imagists, Solomon R. Guggenheim Museum, New York, October 13–December 31.

1963

Black and White, Jewish Museum, New York, December 12–February 1964.

1965

New York School—The First Generation: Paintings of the 1940s and 1950s, Los Angeles County Museum of Art, July 16–August 1.

1966

The American Landscape: A Changing Frontier, National Collection of Fine Arts, Smithsonian Institution, Washington, D.C., April 28–June 19.

1967

Selection 1967: Recent Acquisitions in Modern Art, University Art Gallery, University of California, Berkeley, June 20–September 10.

The New York Painter: A Century of Teaching: Morse to Hofmann, Marlborough-Gerson Gallery, New York, September 27–October 14.

1968

The 1930's: Painting and Sculpture in America, Whitney Museum of American Art, October 15–December 1.

1971

The Structure of Color, Whitney Museum of American Art, February 25–April 18.

1976

The Golden Door: Artist-Immigrants of America, 1876–1976, Hirshhorn Museum and Sculpture Garden, Smithsonian Institution, Washington, D.C., May 20–October 20.

1977

Provincetown Painters, 1890's–1970's, Everson Museum of Art, Syracuse, New York, April 1–June 6, and tour.

1978

Abstract Expressionism: The Formative Years, Herbert F. Johnson Museum of Art, Cornell University, Ithaca, New York, March 28–May 14, and tour.

1979

Hans Hofmann as Teacher: Drawings by His Students, Metropolitan Museum of Art, New York, January 23–March 4.

1980

The Fifties: Aspects of Painting in New York, Hirshhorn Museum and Sculpture Garden, May 22–September 21.

1981

Tracking the Marvelous, Grey Art Gallery, New York University, April 28–May 30.

1982

Hans Hofmann as Teacher: Drawings by Hofmann and His Students, Bass Museum, Miami, December 12–February 6, 1983, and American Federation of Arts tour.

1983

Abstract Painting and Sculpture in America, 1927–1944, Museum of Art, Carnegie Institute, November 5–December 31, and tour.

1984

American Masters: The Thyssen-Bornemisza Collection, Vatican Museums, Rome, and International Exhibitions Foundation tour, 1984–86.

1986

The Interpretive Link: Abstract Surrealism into Abstract Expressionism, Works on Paper, 1938–48, Newport Harbor Art Museum, Newport Beach, California, July 11–September 14, and tour.

112. *The Bouquet*, 1959
Oil on canvas, 50 x 40 in.
University Art Museum, University of
California, Berkeley; Gift of the artist

Public Collections

Andover, Massachusetts, Addison Gallery of American Art

Ann Arbor, Michigan, University of Michigan Museum of Art

Atlanta, Georgia, High Museum of Art

Austin, Texas, Michener Collection, University Art Museum, University of Texas at Austin

Baltimore, Maryland, Baltimore Museum of Art

Berkeley, California, University Art Museum, University of California

Boston, Massachusetts, Museum of Fine Arts, Boston

Brooklyn, New York, Brooklyn Museum

Buffalo, New York, Albright-Knox Art Gallery

Canberra, Australia, Australian National Gallery

Champaign, Illinois, Krannert Art Museum, University of Illinois

Chattanooga, Tennessee, Hunter Museum of Art

Chicago, Illinois, Art Institute of Chicago

Chicago, Illinois, Museum of Contemporary Art

Cincinnati, Ohio, Cincinnati Art Museum

Cleveland, Ohio, Cleveland Museum of Art

Corpus Christi, Texas, University Art Museum, University of Texas

Dallas, Texas, Dallas Museum of Fine Arts

Dayton, Ohio, Dayton Art Institute

Detroit, Michigan, Detroit Institute of Arts

Fort Dodge, Iowa, Blanden Memorial Art Gallery

Fort Worth, Texas, Fort Worth Art Museum

Greensboro, North Carolina, Weatherspoon Art Gallery, University of North Carolina

Grenoble, France, Musée de Peinture et de Sculpture

Honolulu, Hawaii, Honolulu Academy of Arts

Houston, Texas, Museum of Fine Arts, Houston

Indianapolis, Indiana, Indianapolis Museum of Art

Lawrence, Kansas, Spencer Museum of Art, University of Kansas

Lincoln, Massachusetts, De Cordova Museum

London, England, Tate Gallery

Minneapolis, Minnesota, Walker Art Center

Montreal, Quebec, Montreal Museum of Fine Arts

New York City, New York, Grey Art Gallery and Study Center, New York University

New York City, New York, Metropolitan Museum of Art

New York City, New York, Museum of Modern Art

New York City, New York, Solomon R. Guggenheim Museum

Norfolk, Virginia, Chrysler Museum

Oberlin, Ohio, Allen Memorial Art Museum, Oberlin College

Philadelphia, Pennsylvania, Philadelphia Museum of Art

Pittsburgh, Pennsylvania, Museum of Art, Carnegie Institute

Princeton, New Jersey, Art Museum, Princeton University

Purchase, New York, Neuberger Museum

Rochester, New York, Memorial Art Gallery of the University of Rochester

St. Louis, Missouri, St. Louis Art Museum

St. Louis, Missouri, Washington University Gallery of Art

San Francisco, California, Museum of Modern Art

Santa Barbara, California, Santa Barbara Museum of Art

Saskatchewan, Canada, Norman Mackenzie Art Gallery, University of Regina

Toledo, Ohio, Toledo Museum of Art

Toronto, Ontario, Art Gallery of Ontario

Washington, D.C., Corcoran Gallery of Art

Washington, D.C., Hirshhorn Museum and Sculpture Garden, Smithsonian Institution

Washington, D.C., National Museum of American Art, Smithsonian Institution

Wichita, Kansas, Edwin A. Ulrich Museum of Art, Wichita State University

Williamstown, Massachusetts, Williams College Museum of Art

Wilmington, Delaware, Delaware Art Museum

Wilmington, Delaware, Wilmington Society of Fine Arts

Worcester, Massachusetts, Worcester Art Museum

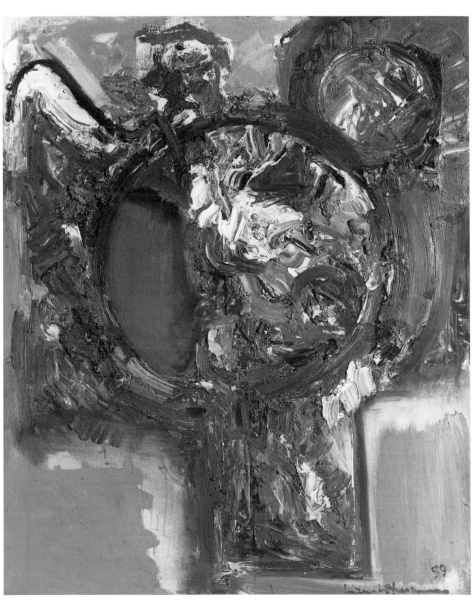

Selected Bibliography

Interviews, Statements, and Writings

Hayes, Bartlett H., Jr., and Weeks, Sara T., eds. *The Search for the Real and Other Essays,* exhibition catalog. Andover, Mass.: Addison Gallery of American Art, 1948. Reprinted by Cambridge: MIT Press, 1968. Includes "The Search for the Real in the Visual Arts," pp. 46–54; "Sculpture," pp. 55–59; "Painting and Culture," pp. 60–64; excerpts from the teaching of Hans Hofmann adapted from his essays "On the Aims of Art" and "Plastic Creation," pp. 65–76; "Terms," pp. 76–78.

Hofmann, Hans. "Art in America." *Art Digest* 4 (August 1930): 27.

———. "Form und Farbe in der Gestaltung." Written in German at the University of California, Berkeley, 1931. Translated by Glenn Wessels as "Creation in Form and Color: A Textbook for Instruction in Art." Rewritten during the winter of 1933–34, in New York, as "Das Malerbuch: Form und Farbe in der Gestaltung." Translated by Peggy Huck, 1949–50. Forthcoming edition, edited by Cynthia Goodman, to be published by Horizon Press.

———. Statement in *Daily Californian*, June 25, 1931.

———. "Painting and Culture." *Fortnightly* (Campbell, Calif.) I (September 11, 1931): 5–7.

———. "On the Aims of Art." Translated by Ernst Stolz and Glenn Wessels. *Fortnightly* (Campbell, Calif.) I (February 26, 1932): 7–11.

———. "Plastic Creation." *League* (published by the Art Students League, New York) 5 (Winter 1932–33): 11–15, 21. Translated from the German. Reprinted in *League* 22 (Winter 1950): 3–6.

———. Statement in *Hans Hofmann: Recent Paintings,* exhibition announcement. New York: Kootz Gallery, 1949.

———. "Space Pictorially Realized through the Intrinsic Faculty of the Colors to Express Volume." In *Hans Hofmann: New Paintings,* exhibition catalog, p. 4. New York: Kootz Gallery, 1951.

———. Statement in *Hans Hofmann,* exhibition catalog. New York: Kootz Gallery, 1952.

———. "The Mystery of Creative Relations." *New Ventures,* July 1953, pp. 22–23.

———. "The Resurrection of the Plastic Arts." *New Ventures,* July 1953, pp. 20–23. Reprinted in *Hans Hofmann: New Paintings,* exhibition catalog, pp. 2–3, New York: Kootz Gallery, 1954.

———. "The Color Problem in Pure Painting: Its Creative Origin." In *Hans Hofmann,* exhibition catalog, pp. 2–4. New York: Kootz Gallery, 1955. Reprinted in *Arts and Architecture* 73 (February 1956): 14–15, and in Sam Hunter, *Hans Hofmann,* New York: Harry N. Abrams, 1963.

———. "Nature and Art. Controversy and Misconceptions." In *Hans Hofmann: New Paintings,* exhibition catalog, pp. 3–4. New York: Kootz Gallery, 1958.

———. Statement in *It Is* 3 (Winter 1958–Spring 1959): 10.

———. "Space and Pictorial Life." In *It Is* 4 (Autumn 1959): 10.

———. "Hans Hofmann on Art." *Art Journal* 22 (Spring 1963): 180, 182. Speech delivered at inauguration of Hopkins Center, Dartmouth College, November 17, 1962.

———. "The Painter and His Problems: A Manual Dedicated to Painting." Thirty-five-page typescript, March 21, 1963. Museum of Modern Art Library, New York.

———. "Selected Writings on Art." Undated 117-page typescript compiled by William Seitz, 1963. Museum of Modern Art Library, New York.

Jaffe, Irma. "A Conversation with Hans Hofmann." *Artforum* 9 (January 1971): 34–39. Interview.

Kuh, Katharine. *The Artist's Voice: Talks with Seventeen Artists,* pp. 118–29. New York: Harper and Row, 1962. Interview.

van Okker, William H. "Visit with a Villager: Hans Hofmann." *Villager* (Greenwich Village), March 18, 1965. Interview.

Wolf, Ben. "The Digest Interviews Hans Hofmann." *Art Digest* 19 (April 1, 1945): 52. Interview.

Monographs and Solo-Exhibition Catalogs

Bannard, Walter Darby. *Hans Hofmann,* exhibition catalog. Houston: Museum of Fine Arts, 1976.

Geldzahler, Henry. *Hans Hofmann: The Renate Series,* exhibition catalog. New York: Metropolitan Museum of Art, 1972.

Goodman, Cynthia. *Hans Hofmann as Teacher: Drawings by His Students, Hans Hofmann: Provincetown Scenes,* exhibition catalog. Provincetown, Mass.: Provincetown Art Association, 1980.

———. *Hans Hofmann,* exhibition catalog. New York: André Emmerich Gallery, 1981.

———. "The Hans Hofmann School and Hofmann's Transmission of European Modernist Aesthetics to America." Ph.D. dissertation, University of Pennsylvania, 1982.

Greenberg, Clement. *Hofmann.* Paris: Editions Georges Fall, 1961.

Hunter, Sam. *Hans Hofmann*. New York: Harry N. Abrams, 1963.

Loran, Erle. *Recent Gifts and Loans of Paintings by Hans Hofmann*, exhibition catalog. Introduction by Herschel B. Chipp. Berkeley: University of California, 1964.

Rose, Barbara. *Hans Hofmann: Drawings, 1930-1944*, exhibition catalog. New York: André Emmerich Gallery, 1978.

Sandler, Irving. *Hans Hofmann: The Years 1947-1952*, exhibition catalog. New York: André Emmerich Gallery, 1976. Reprinted as "Hans Hofmann and the Challenge of Synthetic Cubism," *Arts Magazine* 50 (April 1976): 103-5.

Seitz, William. *Hans Hofmann*, exhibition catalog. New York: Museum of Modern Art, 1963.

Varley, Christopher. *Hans Hofmann, 1880-1966: An Introduction to His Paintings*, exhibition catalog. Edmonton, Canada: Edmonton Art Gallery, 1982.

Wight, Frederick S. *Hans Hofmann*, exhibition catalog. Berkeley and Los Angeles: University of California Press, 1957.

Periodicals, Books, and Group-Exhibition Catalogs

Abbey, R. D. "Color: Man and Nature." *Art Journal* 31 (Fall 1971): 110-12.

"Art for the Office Lobby: Mosaic Elevator Shaft." *Interiors* 116 (February 1957): 85.

Ashton, Dore. "Hans Hofmann: An Appreciation." *Cimaise* 6 (January-March 1959): 38-45.

_____. *The New York School: A Cultural Reckoning*. New York: Viking Press, 1972.

Baker, Elizabeth C. "Tales of Hofmann: The 'Renate Series.'" *Artnews* 71 (November 1972): 39-41.

Bannard, Walter Darby. "Hofmann's Rectangles." *Artforum* 7 (Summer 1969): 38-41.

_____. "Notes on an Auction." *Artforum* 9 (September 1970): 62-64.

Bayl, Friedrich. "Hans Hofmann in Deutschland." *Art International* 6 (September 1962): 38-44. Reprint of catalog essay for Neue Galerie im Kunstler Haus München exhibition.

Bird, Paul. "Hofmann Profile." *Art Digest* 25 (May 15, 1951): 6-7.

Bultman, Fritz. "The Achievement of Hans Hofmann." *Artnews* 62 (September 1963): 43-

45, 54-55. Review of exhibition at Museum of Modern Art, New York.

_____. "Hofmann's Modernism." *Art/World* 5 (December 18, 1980-January 15, 1981): 1, 9.

Burckhardt, Rudolph. "Repertory of Means: *Bald Eagle* by Hans Hofmann." *Location* 1 (Spring 1963): 67-72. Photographic essay.

Cheney, Sheldon. *Expressionism in Art*. 2d rev. ed. New York: Tudor, 1948.

Coates, Robert M. "A Hans Hofmann Retrospective." *New Yorker* 33 (May 11, 1957): 104-6. Review of exhibition at Whitney Museum of American Art.

de Kooning, Elaine. "Hans Hofmann Paints a Picture." *Artnews* 48 (February 1950): 38-41, 58-59.

Devree, Howard. "A Veteran Surprises." *New York Times*, May 3, 1953, section 2, p. 8. Review of exhibition at Kootz Gallery.

Ellsworth, Paul. "Hans Hofmann: Reply to Questionnaire and Comments on Recent Exhibition." *Arts and Architecture* 66 (November 1949): 46.

Fitzsimmons, James. "Hans Hofmann." *Everyday Art Quarterly* 28 (1953): 23-26.

Forgey, Benjamin. "The Restless Experiments of Hans Hofmann." *Artnews* 75 (February 1977): 62-63. Review of exhibition at Hirshhorn Museum and Sculpture Garden.

Geldzahler, Henry. *New York Painting and Sculpture, 1940-1970*, exhibition catalog. New York: E. P. Dutton and Co. in association with the Metropolitan Museum of Art, 1969.

Genauer, Emily. "One-Man Movement in U.S. Art. Hofmann Solo at Whitney Museum, Abstract Annual." *New York Herald Tribune*, April 28, 1957, section 6, p. 14. Review of exhibition at Whitney Museum of American Art.

_____. "Hans Hofmann—Medium Plus Message." *World Journal Tribune*, January 29, 1967, p. 35. Review of exhibition at André Emmerich Gallery.

Goodman, Cynthia. "Hans Hofmann as Teacher." *Arts Magazine* 53 (April 1979): 22-28.

Gouk, Alan. "Essay on Painting." *Studio International* 180 (October 1970): 145-49.

Greenberg, Clement. "Art." *Nation* 160 (April 21, 1945): 469. Review of exhibition at Gallery 67.

_____. "The Present Prospects of American Painting and Sculpture." *Horizon*, October 1947, pp. 20-30.

_____. "American-Type Painting." *Partisan Review* 22 (Spring 1955): 179-96.

_____. "Hans Hofmann: Grand Old Rebel." *Artnews* 57 (January 1959): 26-29, 64.

_____. *Art and Culture*. Boston: Beacon Press, 1961.

Gruen, John. "The Creative Fountain of Youth." *New York Herald Tribune*, March 1, 1964, p. 34. Includes statements by Hofmann.

"Hans Hofmann Continues Despite War." *Art Digest* 16 (May 15, 1942): 29.

"Hans Hofmann." *Derrière le Miroir* 16 (January 1949). Includes Charles Estienne, "Hofmann ou la lumière américaine"; Weldon Kees, "A Salvo by Hans Hofmann"; Peter Neagoe, "Hans Hofmann", Tennessee Williams, "An Appreciation."

"Hans Hofmann: 1880-1966." *Newsweek* 67 (February 28, 1966): 85. Obituary.

"Hans Hofmann Gift to University of California at Berkeley." *Art Journal* 23 (Summer 1964): 291.

Hess, Thomas. "Hans Hofmann." *Artnews* 45 (March 1946): 53. Review of exhibition at Mortimer Brandt Gallery.

_____. "*Artnews* Visits the Art Schools: Three in Provincetown." *Artnews* 45 (June 1946): 12-13.

_____. "U.S. Painting: Some Recent Directions." *Artnews Annual* (1956): 75-98.

_____. "The Mystery of Hans Hofmann." *Artnews* 63 (February 1965): 39, 54-55.

"Hofmann at Chouinard." *Art Digest* 5 (February 15, 1931): 29.

Irving, Carl. "Regents Okay Berkeley Art Gallery. Hans Hofmann Paintings Will Form Nucleus." *Oakland Tribune*, February 20, 1964, pp. 1, 3.

Jewell, Edward Allen. *New York Times*, March 30, 1947, section 2, p. 10. Review of exhibition at Betty Parsons Gallery.

Kaprow, Allan. "Effect of Recent Art upon the Teaching of Art." *Art Journal* 23 (Winter 1963-64): 136-38.

_____. "Hans Hofmann." *Village Voice* 9 (February 24, 1966): 1-2.

Kepes, Gyorgy. "Hans Hofmann: *Search for the Real*." *Magazine of Art* 45 (March 1952): 136-37. Book review.

Kootz, Samuel M. "Credibility of Color: Hans Hofmann." *Arts Magazine* 41 (February 1967): 37-39.

Kramer, Hilton. "Symbol of Change: Hofmann, Teacher, Theorist, and Artist, Codified and Passed on Modern Legacy." *New York Times*, February 18, 1966, p. 33. Obituary.

_____. "Hofmann in Perspective." *New York Times*, January 29, 1967, sec. 2, p. 25. Review of exhibition at André Emmerich Gallery.

Kroll, Jack. "Old Man Crazy about Painting." *Newsweek* 62 (September 16, 1963): 88, 90. Review of exhibition at Museum of Modern Art.

Landau, Ellen G. "The French Sources for Hans Hofmann's Ideas on the Dynamics of Color-Created Space." *Arts Magazine* 51 (October 1976): 76–81.

Lawson, J. H. "Hans Hofmann." *Arts and Architecture* 61 (March 1944): 23. Review of exhibition at Art of This Century.

Loran, Erle. "Hans Hofmann and His Work." *Artforum* 2 (May 1964): 32–35.

Louden, Lynn M. "Apollo and Dionysius in Contemporary Art." *Arts Magazine* 45 (December 1970): 20–23.

"Master Teacher." *Life* 42 (April 8, 1957): 70–72.

Matter, Mercedes. "Hans Hofmann." *Arts and Architecture* 63 (May 1946): 26–28.

Messer, Thomas. "Kandinsky en Amérique." *XXe Siècle* 28 (December 1966): 111–17.

Millard, Charles W. "Hans Hofmann." *Hudson Review* 30 (Autumn 1977): 404–8.

Morse, J. D. "Artist in America: He Paints Big." *Art in America* 48 (Summer 1960): 76–79.

O'Doherty, Brian. "Art: Profound Changes. Hofmann Display at Kootz Shows He Has Cast His Work into the Melting Pot Again." *New York Times*, January 4, 1962, p. 27. Review of exhibition at Kootz Gallery.

_____. "Hans Hofmann: A Style of Old Age." *New York Times*, September 15, 1963, sec. 2, p. 23. Review of exhibition at Museum of Modern Art.

Plaskett, J. "Some New Canadian Painters and Their Debt to Hans Hofmann." *Canadian Art* 10 (Winter 1953): 59–63.

Pollet, Elizabeth. "Hans Hofmann." *Arts Magazine* 31 (May 1957): 30–33. Review of exhibition at Whitney Museum of American Art.

"Push Answers Pull." *Time* 77 (March 17, 1961): 78–81. Review of exhibition at Kootz Gallery. Includes statements by Hans Hofmann.

Riley, Maude. "Hans Hofmann: Teacher-Artist." *Art Digest* 18 (March 15, 1944): 13.

Harold Rosenberg. "Hans Hofmann: Nature into Action." *Artnews* 56 (May 1957): 34–36. Review of exhibition at Whitney Museum of American Art.

_____. "Tenth St.: A Geography of Modern Art." *Artnews Annual XXVIII*, 57 (November 1959): 120–43, 184–92, passim.

_____. "Hans Hofmann's 'Life' Class." *Portfolio and Artnews Annual* 6 (Autumn 1962): 16–31, 110–15.

_____. "Hans Hofmann and the Stability of the New." *New Yorker* 39 (November 2, 1963): 100, 103–5, 108–10. Review of exhibition at the Museum of Modern Art.

_____. "Hans Hofmann." *Vogue* 145 (May 1965): 192–95, 236.

_____. "Editorial." *Artnews* 65 (April 1966): 21. Eulogy delivered at the artist's funeral on February 20.

_____. "Homage to Hans Hofmann." *Artnews* 65 (January 1967): 49.

_____. "Teaching of Hans Hofmann." *Arts Magazine* 45 (December 1970): 17–19.

_____. "Hofmann Unforgettable as Artist, Teacher." *Advocate Summer Guide* (Provincetown, Mass.), August 7, 1980, pp. 3–25. Review of exhibition at Provincetown Art Association.

Sandler, Irving. *The Triumph of American Painting: A History of Abstract Expressionism.* New York: Praeger, 1970.

_____. "Hans Hofmann at Emmerich." *Art in America* 60 (March 1972): 118–19. Review of exhibition at André Emmerich Gallery.

_____. "Hans Hofmann: The Pedagogical Master." *Art in America* 61 (May 1973): 48–57. Includes statements by students.

Seckler, Dorothy. "Can Painting Be Taught?" *Artnews* 50 (March 1951): 39–40, 63–64. Includes statements by Hofmann.

Seitz, William C. *Abstract Expressionist Painting in America.* Cambridge, Mass., and London: Harvard University Press, 1983.

Tillim, Sidney. "Report on the Venice Biennale." *Arts Magazine* 35 (October 1960): 28–35. Review of exhibition at *XXX Venice Biennale*.

"Trapezoids and Empathy." *Time* 58 (December 3, 1951): 72. Review of exhibition at Kootz Gallery. Includes statements by Hofmann.

Tuchman, Maurice, ed. *New York School—The First Generation: Paintings of the 1940s and 1950s*, exhibition catalog. Los Angeles: Los Angeles County Museum of Art, 1965.

Willard, Charlotte. "Living in a Painting." *Look* 17 (July 28, 1953): 52–55.

Wolf, Ben. "Space and Rhythm." *Art Digest* 20 (March 15, 1946): 15. Review of exhibition at Mortimer Brandt Gallery.

Index

Photographic Credits

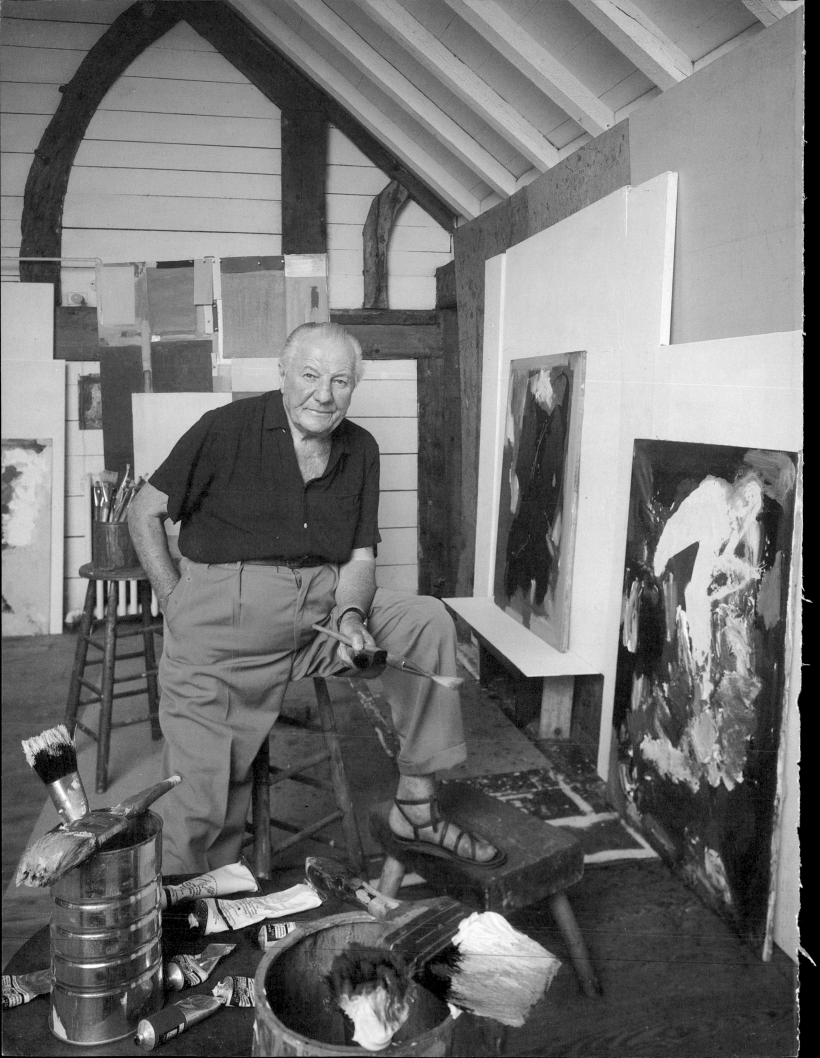